THE ESSENTIAL ● BOOK OF
Drawing
Animals

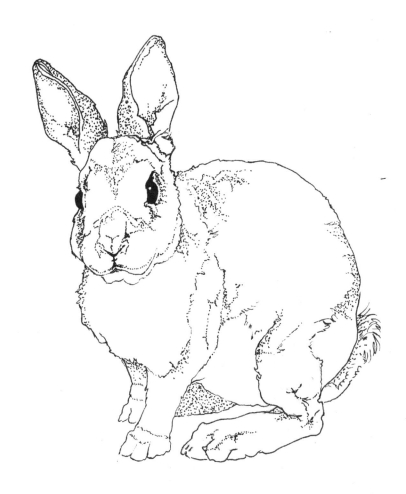

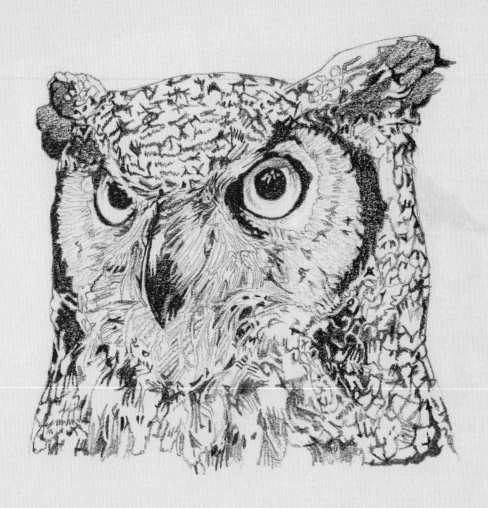

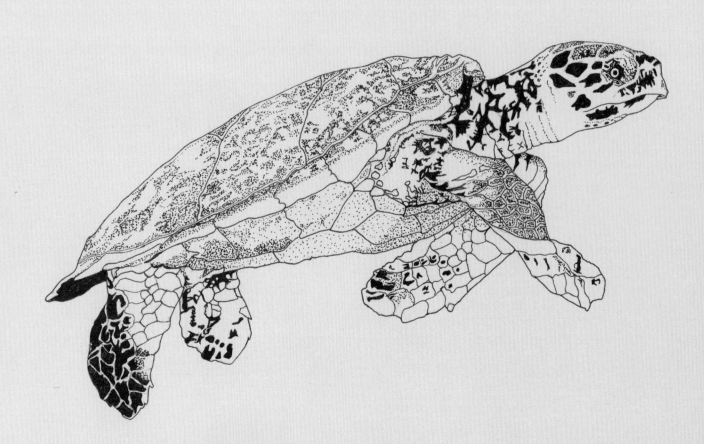

THE ESSENTIAL • BOOK OF
Drawing Animals

THE STEP-BY-STEP GUIDE TO BEAUTIFUL ARTWORK

Aimee Willsher

ARCTURUS

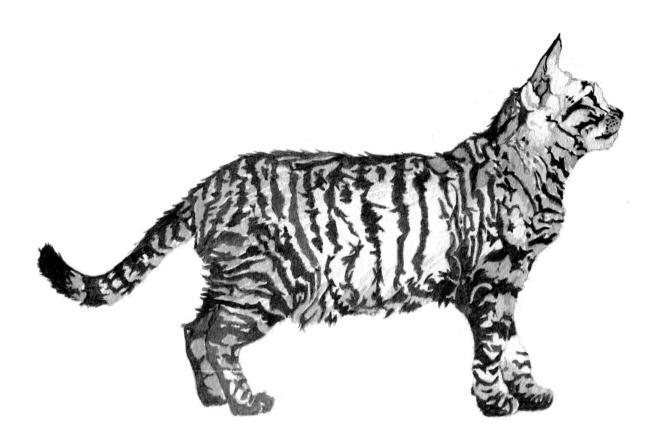

ARCTURUS

This edition published in 2015 by Arcturus Publishing Limited
26/27 Bickels Yard, 151–153 Bermondsey Street,
London SE1 3HA

Copyright © 2015 Aimee Willsher
Design copyright © Arcturus Holdings Limited

ISBN: 978-1-78404-507-4
AD004360UK

Printed in China

CONTENTS

INTRODUCTION

The animal world provides us with a never-ending source of inspiration for drawing, from the exotic and unusual animals we might see in televised wildlife documentaries to the familiar domestic pets that share our homes. Their forms range from simple to complex, so animals are a great place to start when embarking upon your drawing adventures.

The biggest stumbling blocks when learning any new skill are the initial fear of making mistakes and the worry that you won't live up to your own expectations. We are all human and it's difficult to avoid these anxieties, but with a little help and explanation, a new discipline such as drawing becomes a breeze! Hardly anyone would be intimidated by the thought of making a representation of the humble goldfish, for example, so there are plenty of opportunities to start small. Once your confidence grows you'll think nothing of sketching more complicated animal forms and you'll probably seek out the most testing subjects to stretch your newfound skills.

In this book I'll explain the discipline of representing the solid form on a flat piece of paper and show how easy it is to create the illusion of three dimensions. Any form, no matter how complex it appears at first glance, can be broken down into a series of interlocking primary shapes that fit together to create an outline. Paring forms down to their basic simple elements makes the process of starting less daunting – everyone can draw a square, circle and triangle, so it follows that with a little instruction, everyone can draw!

GETTING STARTED

All you really need to get started is a pencil and some paper, though as you progress and become a bit more ambitious and experimental you will obviously want to expand your range of artist's materials.

So, start by equipping yourself with the simple essentials, remember how easily and unselfconsciously you used a pencil when you were a child and begin drawing with optimism. It won't be long before you are determined to tackle almost any subject in the animal world!

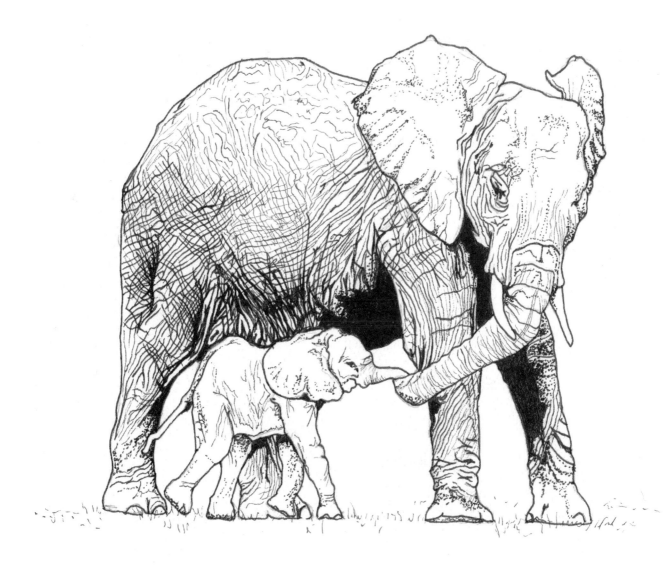

Essential Materials and Accessories

Watersoluble
pencil

There are many brands of art materials and the variety that will confront you when you walk into an art supplies shop may be offputting. However, most essential equipment is inexpensive and therefore there is room for experimentation. You only need a few key materials to enable your techniques to evolve.

PAPER

Drawing paper is available in a variety of weights and textures. When you are buying a sketch pad, look on the front for a weight grading. The higher the prefixing number, the thicker the paper. For example, 120gsm, or 120g/m2 (75lb) is quite thin but fine for making quick, rough sketches. If you want to start using paint or blending pencil with wet brushes it is a good idea to buy a more robust heavyweight watercolour paper of 300gsm (140lb) as it can withstand water application without curling or perforating. Also look out for the texture or 'grain' of the paper. Paper with a fine grain is perfect for working with charcoal and pastel, because the slight texture gives your medium something to engage with.

PENCILS

Propelling
pencil

Pencils are graded from hard to soft according to the density of their leads, the harder leads being H to 9H and softer leads B to 9B. The higher the number, the harder or softer the lead. The trusty HB pencil falls bang in the middle of the scale. Hard leads are good for making fine, definite lines, while softer leads are great for shading and blending. Propelling pencils are also very useful; they usually look like pens and carry a fine lead which can be 'propelled' forward as it is worn down. These pencils are useful for making precise lines and maintain their fine point, thereby avoiding constant sharpening.

Watersoluble pencils are a great place to start when you feel you are ready for a little experimentation. Just use them to shade an area like you would with a normal pencil and then take a wet brush and begin to blend the marks. You can achieve wonderfully subtle gradated tones and the discipline will lead you easily into experimenting with brushes and paint. See chapter 2 (page 34) for more information and examples of work using watersoluble pencils.

PENS

Double-ended
brush pen/felt-tip

Ink drawings have a wonderful intensity and clarity. Fineliner pens are great for creating clear outlines and can be used to add surface interest with stippling or crosshatching techniques (see page 11). Brush pens are good for making bolder graphic drawings; they are watersoluble and can therefore be blended like paint to achieve gradated tone.

ERASERS

The beauty of working in pencil is that when you make a mistake there's no drama – you can just rub it out! Hard plastic erasers are good for removing large areas of pencil. Putty rubbers are soft and can be moulded into a point with your fingers, which allows you to erase specific small areas.

SHARPENERS

Sharp pencils make the cleanest, most precise lines. Having a good sharpener close to hand while you draw is essential to maintain the clarity of your outlines.

BLENDING STICKS

Also known as tortillons, these are great for creating soft gradations of tone. You can buy them, but they are easy to make. Simply cut a rectangle out of an old newspaper, roll it tightly into a stump and fasten it in place with some sticky tape. Use your stick to blend shaded areas.

Tortillon

SURFACE AND LIGHT

A good drawing can be created anywhere, but you need to have a flat surface, whether it be a table or a sturdy sketchbook, so that you can be sure of making your marks with confidence and purpose.

Light is also very important to any artist, so don't make your life hard by working in a dimly lit room; an angled table lamp is perfect for focusing a good source of light on to a specific spot. Of course the best light of all is daylight, and this provides a great excuse to sit outside on a beautiful sunny day with your sketchbook in hand.

Basic Techniques

Before you start drawing some subjects, there are a few basic techniques you need to know. They are all simple and the more you use them the more confident your mark-making will become. Other than line drawing, the techniques are used to describe tone – the light and dark areas in a drawing that will convey the form of your subjects and make them look three-dimensional.

THE OUTLINES

These are the most basic and fundamental marks and they will be essential in almost every drawing you make. The outlines are the initial marks that will establish the form of your drawing and ultimately make your subject matter recognizable. You can vary an outline by changing the pressure you put on your pencil – for a light outline use light pressure and for a bold, heavy outline increase the pressure.

SHADING

This technique is familiar to anyone who has ever filled in a colouring book. Apply your pencil to the paper with a back and forth motion, varying the pressure to lighten or darken the tone of the shading. You can blend your shading by rubbing a tortillon back and forth over the surface.

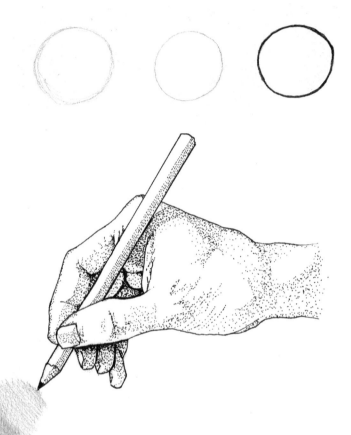

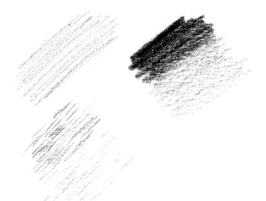

HATCHING

Using your drawing tool to make a series of short lines over an area is a versatile technique, since varying the spacing between the lines greatly changes the surface appearance. Closely spaced hatching creates a soft textural effect and intense shading; widening the hatched lines gives a rugged texture and light tonal variation.

CROSSHATCHING

As you might expect from the name, this technique is an elaboration on hatching. It is simply a matter of adding a second set of lines going in the opposite direction to the first. Curving the crosshatched lines enables you to describe undulating surfaces.

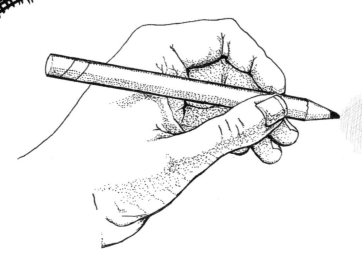

STIPPLING

This is another way of adding tone and texture to the paper. Make a series of small dots over the area you want to shade. Closely spaced dots create deep tone, while widening the spaces between the dots lightens the tone and adds texture to the surface.

SCUMBLING

For soft shading, the scumbling technique is ideal. Make sure your pencil is softened to a rounded point and use small circular motions to apply your marks to the paper. You can also scumble using charcoal and chalk; with these materials you can overlay different tones to enhance the depth and texture of the surface.

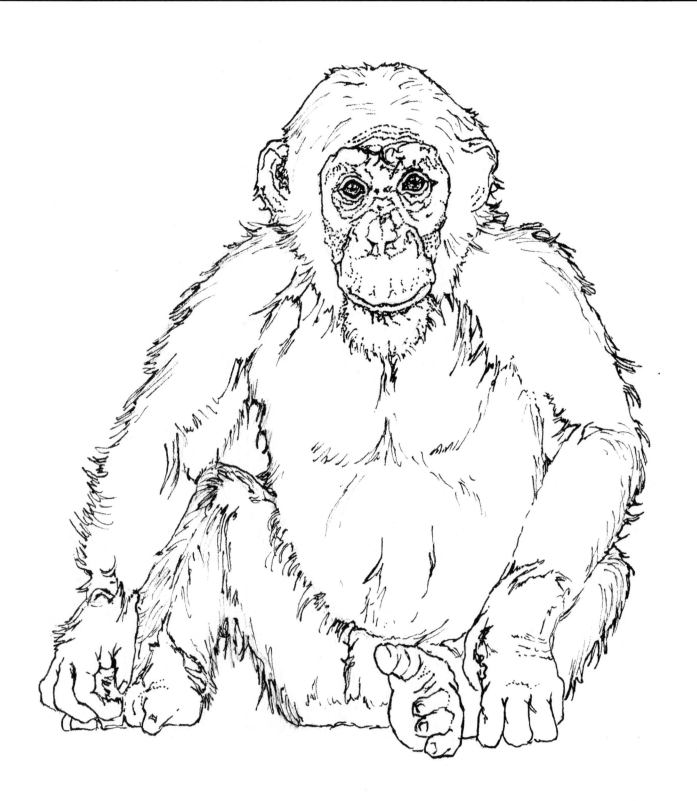

Chapter 1

CREATING FORM

Here's the good news: the primary shapes that you learned to draw in early childhood can be used to help you draw any object you can imagine, no matter how complicated. It's learning how to look at form in a new way that takes some practice. When you gaze at a field full of sheep, for example, you need to engage your mind like an artist with a potential drawing in mind. Those animals are made up of a body, head and four legs; what simple shapes best describe these individual body parts? Once you start to simplify complex forms into their components you will soon be able to draw all creatures, large or small, feathered or furred.

In this chapter we shall start from the very beginning, looking at the primary building blocks of form. We shall then examine how these shapes can be amalgamated to create recognizable outlines. Once you are familiar with drawing the outline of a particular animal you will no longer need the safety net of simple shapes; you can then focus on how to turn your two-dimensional outline into a living, breathing physical presence.

Primary Shapes

I have made a series of very quick sketches of a variety of creatures to show how simple shapes can rationalize a more complicated entity in your mind, making the subject a less daunting project to tackle.

These simple flat shapes are easy to draw and can be used in combination to create an endless variety of animal forms. You can see how a few simple circles connected with some lines can very quickly be used to form the outline of a horse.

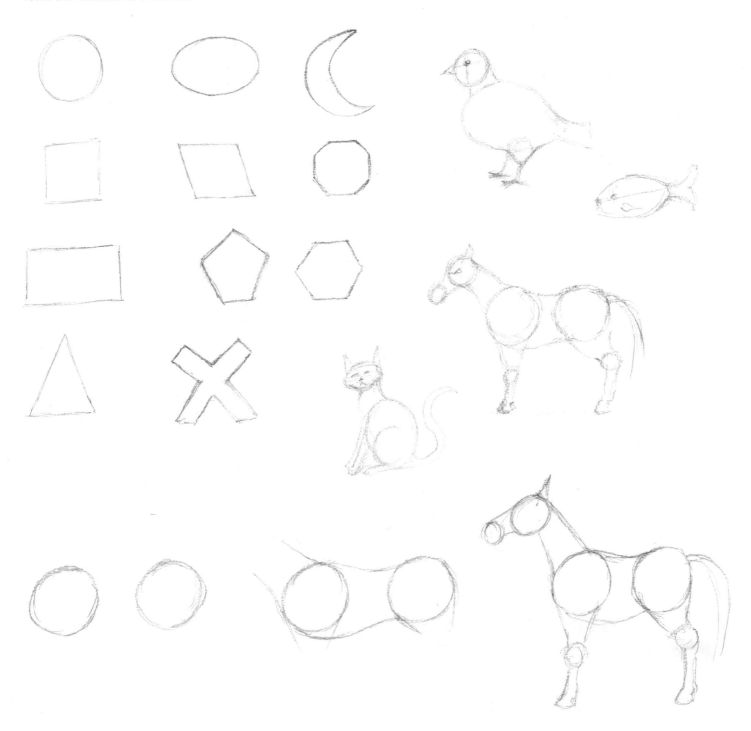

The Illusion of Three Dimensions

One of the biggest feats when you are learning to draw is starting to make your pictures appear three-dimensional. This, of course, is about learning the tricks of creating an illusion, since the piece of paper will always be flat; it is a matter of making your marks so that your drawn image imitates what our eyes see in the world around us. This drawing sequence shows how easy it is to turn a flat two-dimensional shape into a solid form using a few simple linear additions and shading.

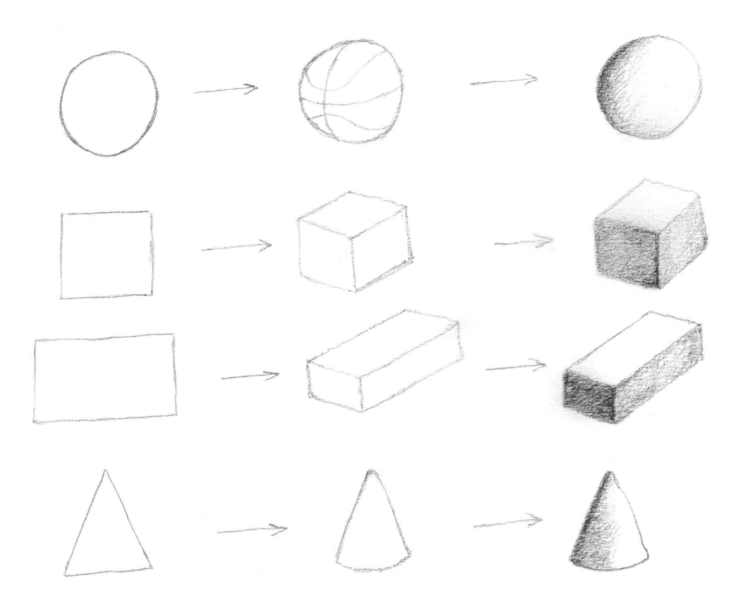

There are a few simple techniques which will help you to improve your powers of perception and allow you to translate solidity into your drawings.

SHADING

We have already seen how adding shading on a simple shape like a circle can turn that circle into a sphere – a solid three-dimensional form. This shading technique can be applied to more complicated animal forms to enhance the feeling of their real shape. Adding a cast shadow beneath the form you are trying to represent also adds to its feeling of presence and solidity.

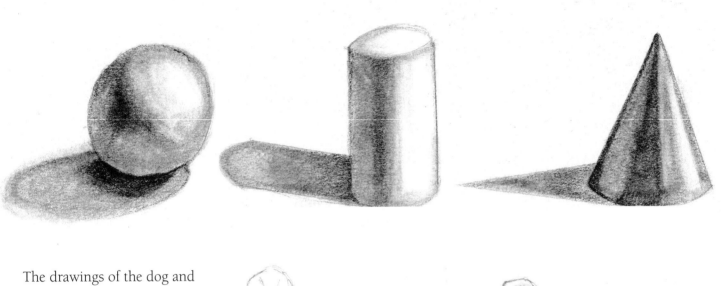

The drawings of the dog and elephant come to life with a few strategically placed smudges of shading. Make sure that when you are embarking upon a drawing in the early stages you keep your pencil work very light so that it is easily erasable and won't show in the finished work.

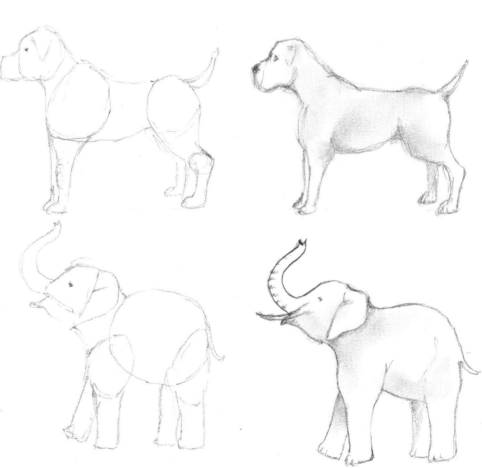

CROSS-CONTOUR DRAWING

With this technique the illusion of three dimensions is created entirely with lines. It involves drawing a series of parallel or radiating lines across the surface of your form to describe its surface. It is a technique that is used to make topographical maps (maps that show where mountains and valleys are located). The closer the lines, the darker the tone. This technique is great for drawing complex curved forms. I have used cross-contour lines to emphasize the curves that make up the form of this baby elephant.

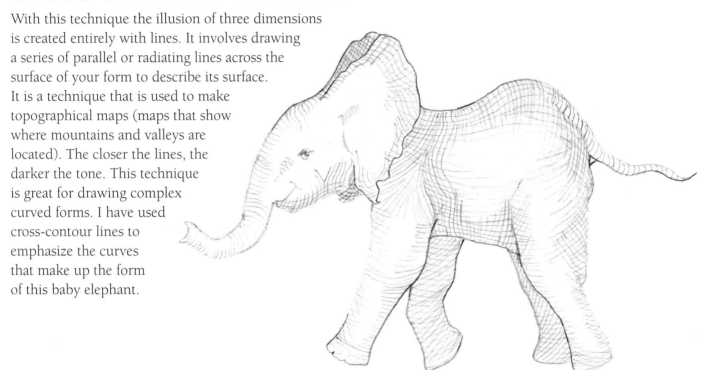

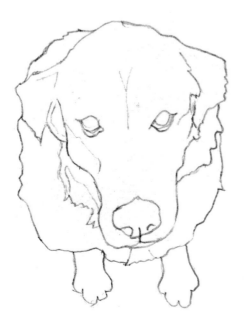

CONTOUR DRAWING

This technique focuses on the outline of a form and conjures the three-dimensionality of a subject by focusing on shape and proportion. It relies heavily on understanding the rules of perspective – so areas that are closer to the observer appear bigger. With this technique you must let the outlines speak for themselves and you need not worry about tone to make your drawings solid. The clear mass of the form speaks for itself, uncomplicated by detail.

You can see the effectiveness of this technique in my drawing of a dog. It is drawn from above and so is subject to extreme foreshortening. The head is the largest form in the drawing while the feet are merely little stumps projecting from the bottom of the form. The shape is not what we would automatically imagine when we think 'dog', but it is a two-dimensional interpretation of what we actually see.

Although this technique appears to be the simplest, it is in fact quite difficult to master – one wrong line and the image loses its power and visual sense. However, with practice, contour drawing can be very successful.

Skeletal Structure

Although you needn't trouble yourself with learning complicated anatomical drawing it's useful to understand how the bones give the body form. I have made simplified line drawings of the skeletons of a generic four-legged animal, a primate, a rodent and a bird. You can easily see how mammals and birds are made up of a skull attached to a spinal cord with ribs radiating outwards to form a protective cage surrounding the vital organs. Once you have understood this basic structure you'll approach your drawing with a greater sensitivity to the form you are about to tackle.

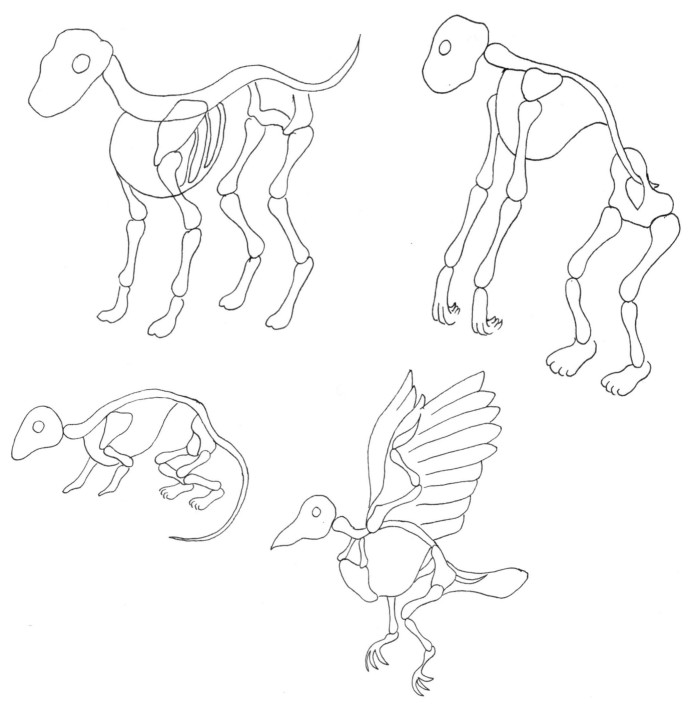

Small Mammals

There are a huge range of small mammals, from the tiny soft mouse to the prickly porcupine! They are a great subject to start with when you are beginning your adventures into drawing animals. They are easily accessible – you only need to walk into a local pet shop and you'll be confronted with a wealth of fluffy subjects to draw. They are also an easy subject for a beginner to tackle. You can see how simply the forms of the gerbil and rabbit have been created.

Birds

There is a huge variety of size, colour and form within the world of birds, from the long-legged flightless ostrich to the tiny vibrant hummingbird. While those species may not be easily available, you can't walk down the street without seeing a bird of some kind perched or in flight. This makes them a great inspiration for the beginner artist.

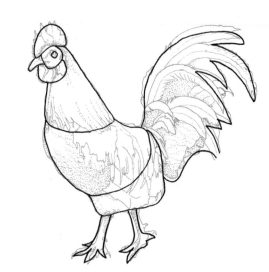

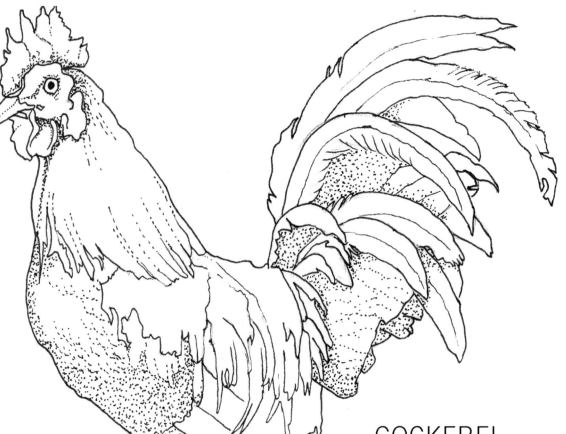

COCKEREL

The most beautiful thing about the male chicken is its amazing tail feathers. When I started my drawing I wanted to balance the form by making the tail the same size as the head and neck. I used stippling to add shadow and texture. There was no need to draw every single feather – in fact, doing this would only over-complicate the drawing. I added detail to a few key tail and body feathers and this was enough to explain the texture of the plumage.

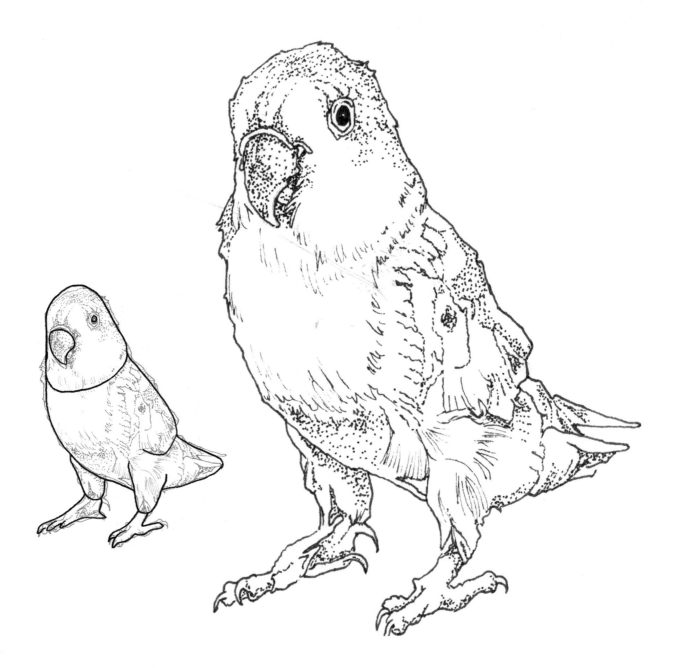

LOVEBIRD

Lovebirds are a small species of parrot with vibrant green, red and yellow plumage. My drawing was created quite simply with a rough cone shape for the head, an oval body and a pointed, tapering tail. I used rough, sketchy lines to describe the feathery texture covering the body.

Reptiles and Fish

Reptiles are cold-blooded animals, so they are very dependent on the warmth in their environment to get them going. One of the most interesting visual features of many reptiles is the geometric patterns that cover their scaly bodies – trying to copy these patterns is a great exercise and makes for eye-catching results. You can see how effective the bold black markings are upon the skin of the snake and the gecko.

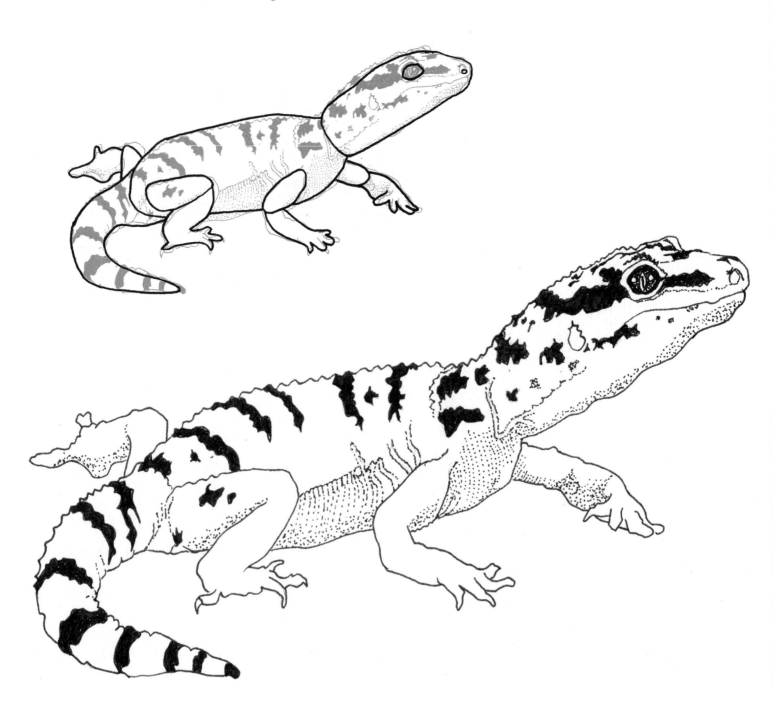

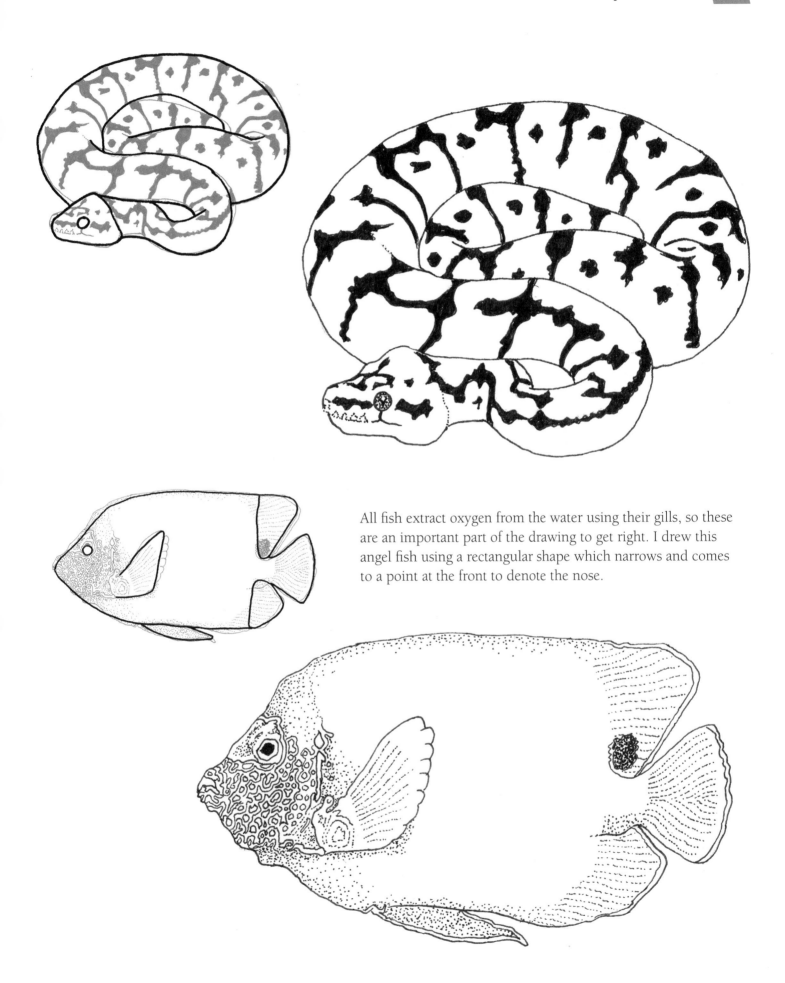

All fish extract oxygen from the water using their gills, so these are an important part of the drawing to get right. I drew this angel fish using a rectangular shape which narrows and comes to a point at the front to denote the nose.

Quadrupeds

A quadruped is an animal that has four legs, so this animal classification covers a wide variety of domestic and wild animals from the horse to the noble tiger. Each animal has the same basic conformation; even a slight variation of line and proportion makes a massive difference. Look at the simple shape structure that I used to create each drawing and try to recreate the outlines for yourself. I used pen and ink, which is a very bold and clear medium, for these drawings.

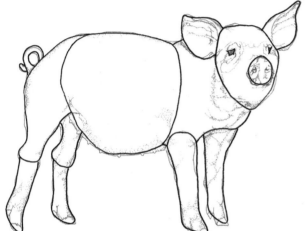

PIG

As the pig is characterized by its round belly, my starting point was naturally a central circular shape. To this I added lines to describe the hindquarters and shoulders, followed by the legs and head. I wanted to let the form of the pig speak for itself and therefore added very little surface detail to my drawing. A few areas of strategically placed stippling are enough to evoke the curve of the belly and the shadows on the legs and face.

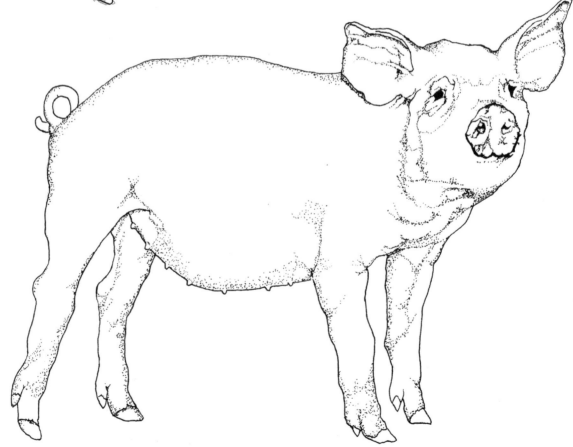

SHEEP

Like the pig, the sheep also has a rounded body mass.
I used a slightly more rectangular shape with rounded
corners. I then added the remaining forms of the limbs
and head to this main core. The main feature of sheep
is of course their woolly coat, and I tried to suggest this
with wavy line detail which I added to the edges of the
body's contours.

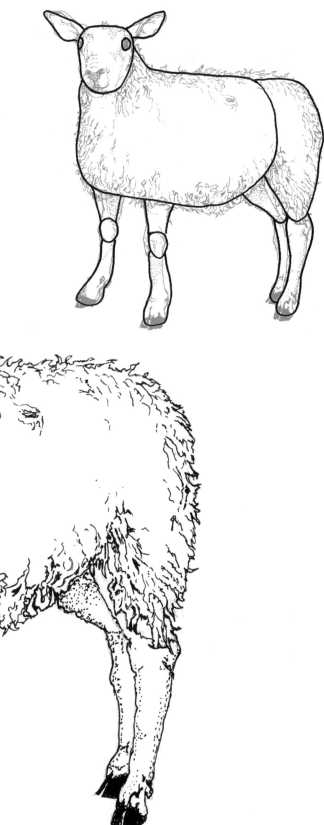

HORSE

Horses have distinctive round rumps and powerful shoulders. I started by drawing two roughly circular forms to denote the front and back of the body. I wanted to capture the sleek muscular contours of the horse, so I put in a variety of stippled shadows to indicate where the muscles lie beneath the skin.

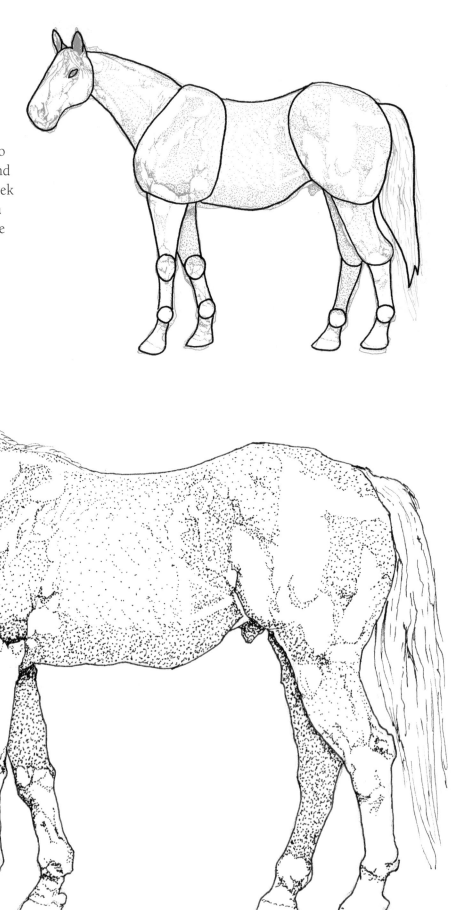

TIGER

I began the outline by drawing a roughly rectangular form to describe the chest and ribcage. To this I added connective lines to the rear haunch and then drew in shapes to form the limbs and head. Obviously the most distinctive feature of a tiger is its stripes. I drew this tiger from a photograph and paid close attention to the pattern on the fur.

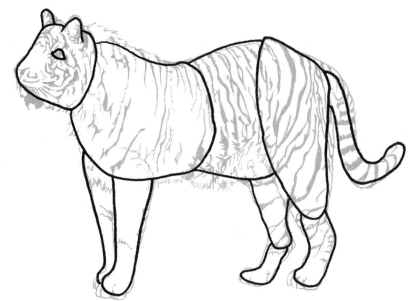

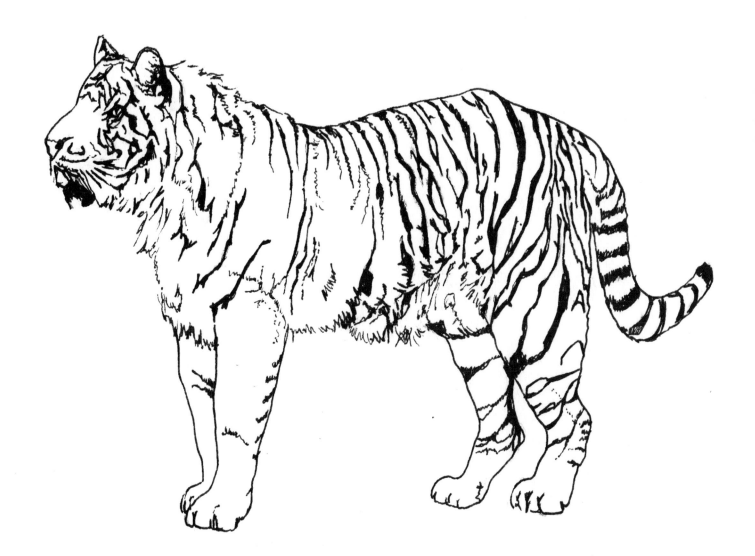

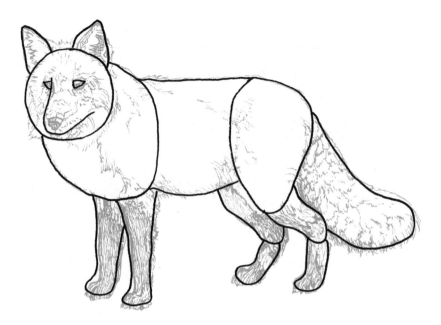

FOX

Like the domestic dog, the fox is a canine. It is a familiar sight to most of us in the countryside and the urban environment alike. Its body is small and compact, with large, alert, pointed ears. Its most distinctive feature is its full fluffy tail, and this, I tried to exaggerate when starting my drawing. I wanted to capture the texture of the fox's fur and used my pen to make small dashed lines following the direction of the lay of the hairs covering the body.

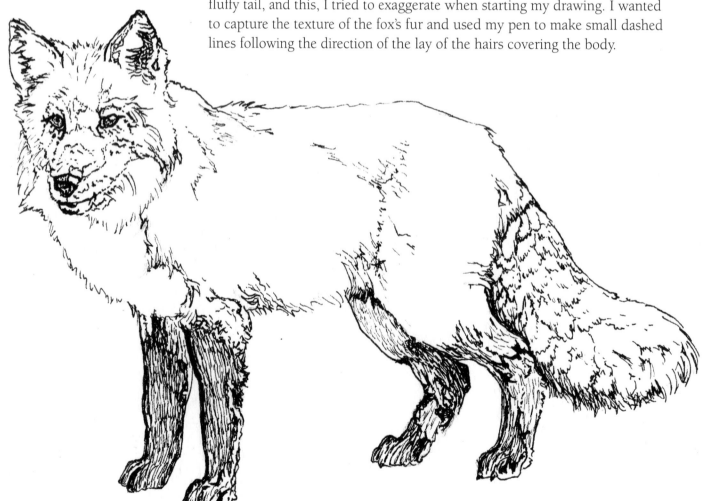

Primates

Our closest living relatives in the animal kingdom, the primates group includes some animals who, like us, have opposable thumbs, a feature that allows them to manipulate tools. This, together with their general high level of intelligence, make them fascinating creatures to observe and draw.

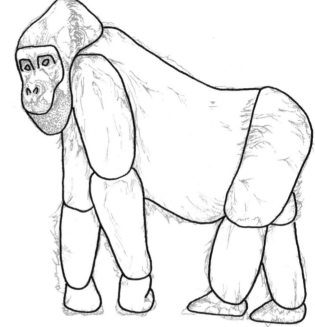

GORILLA

The biggest of the apes, gorillas are well known for their strength and muscular physique. I wanted to emphasize the long arms and broad shoulders and started by drawing two sloping horizontal lines to locate the back and belly. I then added rounded oblong shapes to describe the arms and legs. Gorillas don't have much of a neck and so finally I simply added a few lines to place the head upon the shoulders. I used stippling to add detail to the face. The curves of the body are evoked by some sketchy lines which also add texture and visual interest to the surface of the drawing.

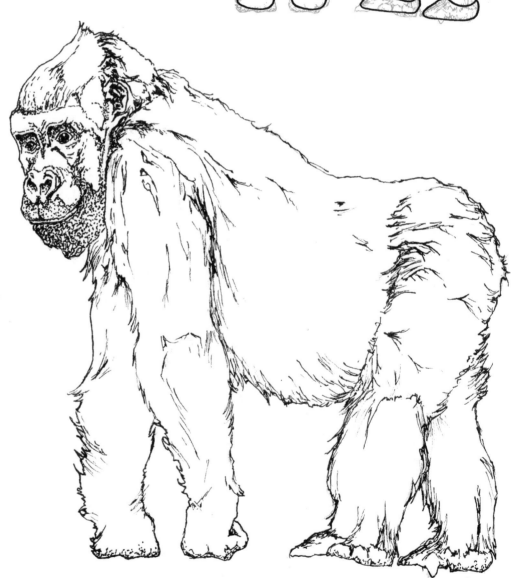

ORANGUTAN AND CHIMPANZEE

These primates are more physically similar to humans than the gorilla. I started both drawings by establishing the central torso and to this I added the forms of the limbs and head. I used photographs as reference for both drawings and paid particular attention to how all the components of the body interacted proportionally. Always think in this way when making a drawing as it will help you to achieve a balanced result that makes sense visually.

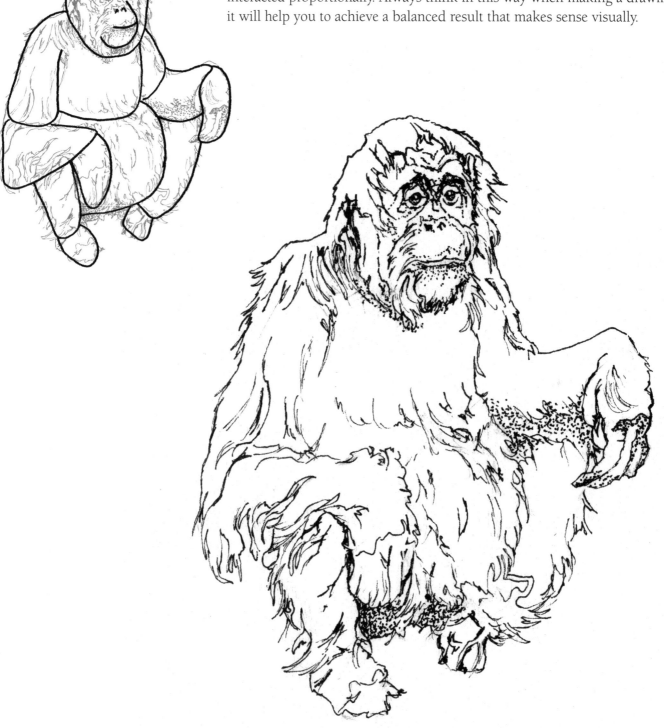

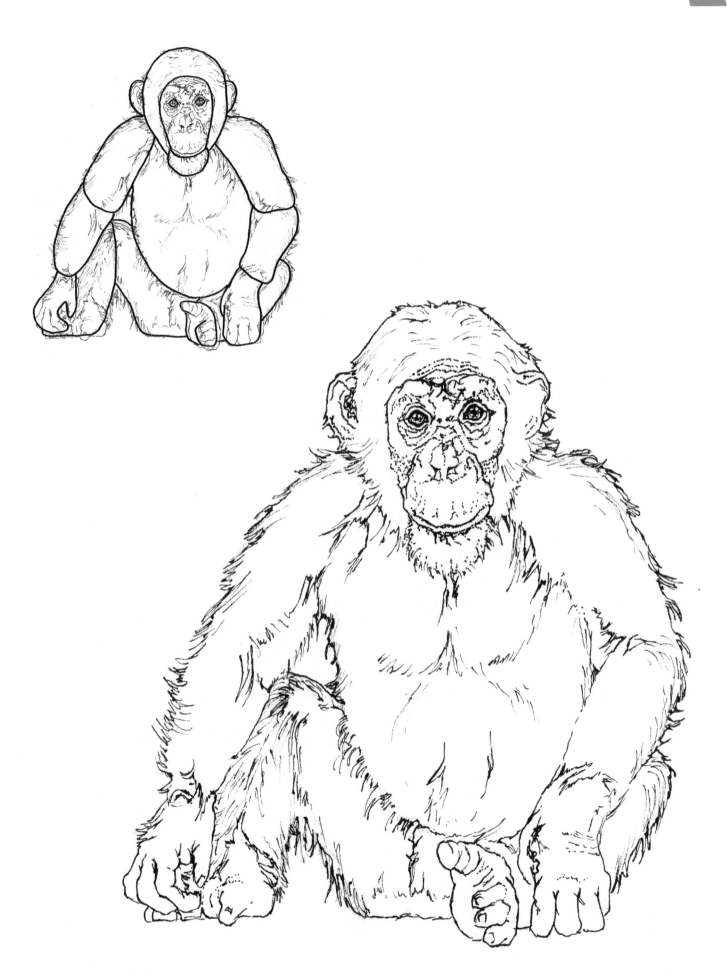

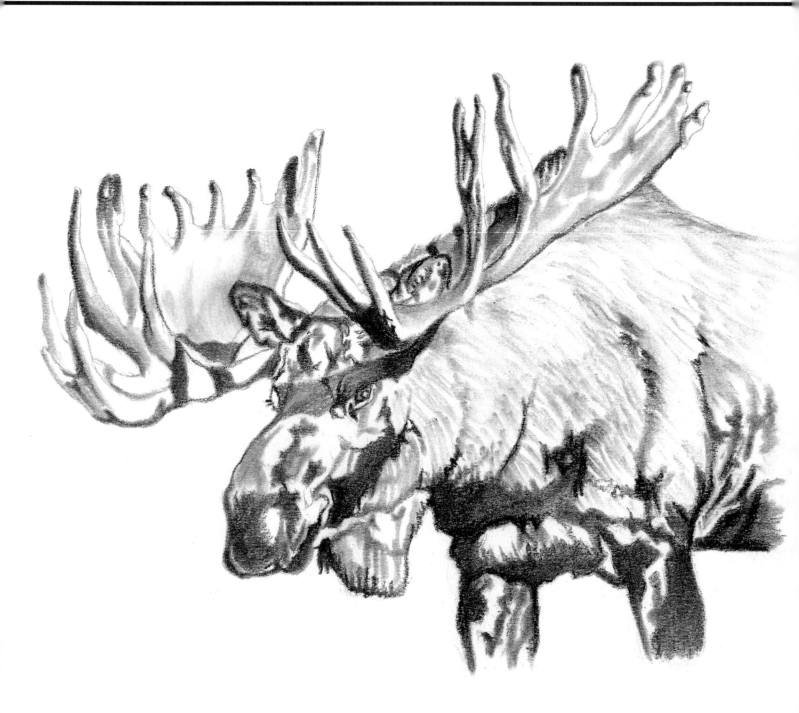

Chapter 2

TONE AND TEXTURE WITH NEW MATERIALS

Now that you have gained the confidence to tackle a variety of animal forms, it's time to start experimenting with your materials. There is such a variety available that making a choice can seem bewildering. However, there are a few classic materials that all master artists have worked with throughout the centuries and we shall begin to explore how and when to use these to take advantage of their particular qualities. We will investigate how to choose the best material to evoke the visual character of a particular animal and how to use it to achieve beautiful, professional-looking results. With each material we will explore a variety of different effects: bold graphic styles, sleek smooth surfaces, soft, rough, spiky textures and tonal contrast. By following the step-by-step examples in this chapter, you'll be able to complete drawing projects in a variety of media and enjoy discovering new skills.

Watersoluble Pencils

Don't be intimidated by the thought of starting a new discipline; we have all been practised users of the humble pencil and paintbrush from early childhood and if you can use a pencil and a brush, the possibilities are endless.

 Watersoluble pencils are a great place to start when embarking upon your experimentations. They are easy to use and can achieve some striking results. These pencils do what the name says – they dissolve in water. However, there are a few key facts that it is helpful to be aware of before you start using them.

Like standard pencils, watersoluble pencils are graded according to their density – an 8B soluble pencil creates dark, intense tone, while an HB pencil makes a light transparent wash. Simply shade your drawing as you would with an ordinary pencil, then, taking a wet brush, moisten the shaded area to achieve smooth blending and soft gradation of tone. Be careful when blending a very soft pencil, as the results can often appear darker and more opaque than you might expect.

 When you start to bring water into your pictures it is a good idea to use a thicker, more robust paper to stop surface disintegration and wrinkling. All good art shops stock a huge variety of inexpensive watercolour sketchbooks.

DOLPHIN: SLEEK FORM

Dolphins are well known for their intelligence and friendly interaction with humans. They are one of the few groups of mammals that spend their entire lives in water and their physical form is adapted to this aquatic existence. They have fins instead of legs and their whole body is streamlined so that they can swim smoothly and quickly through the water. It was this smooth curved form that I wanted to capture in my drawing, using a photograph for reference. I also wanted to experiment with depicting water and its transient reflections. The watersoluble pencil is perfect for depicting the shiny sleekness of the dolphin.

You will need

300gsm (140lb) cartridge paper

HB pencil

HB watersoluble pencil

8B watersoluble pencil

round watercolour brush

(size 4)

STEP 1

Using a regular HB pencil, I started drawing a simple outline of the dolphin's head and nose and put in the waterline just below the eye. I then began to add small cone-shaped teeth to the upper and lower jaw.

STEP 2

I drew in the remaining teeth so that they appeared regular and symmetrical in the dolphin's open mouth. As well as making sure that the outline of the dolphin was accurate, one of my main aims when making this study was to depict a submerged form convincingly. I looked carefully at the shape of the dolphin's body as it appeared distorted by the movement of the water and began to draw a rippled, broken outline beneath the lower jaw.

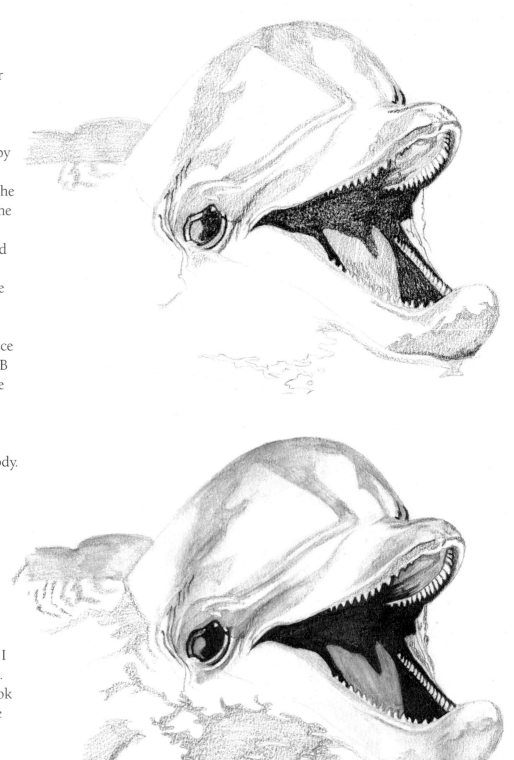

STEP 3

The three-dimensional shape of the dolphin really begins to appear at this stage. It is important to pay close attention to your reference material to understand where to locate your shaded areas. I began by shading in the darkest tones using the 8B watersoluble pencil inside the mouth and around the teeth and the eye. I picked out the shape of the tongue and highlight of the eye and shaded these areas lightly with the HB watersoluble pencil. With these darkest tones established I began to pay attention to the shading of contrasting reflections on the surface of the dolphin's head. I used the HB watersoluble pencil for these subtle shadows. Finally I added another area of shadow behind the back of the head to begin to describe the submerged part of the dolphin's body.

STEP 4

Using my moistened round brush, I started to blend the pencil shading. When blending the dark areas I took care not to lose any clarity of shape around the teeth. I was quite bold with my blending of the shading on the head, pulling the wet pencil solution into the white areas of paper – this really starts to subtly gradate the tones. I then began to add shade and rippled texture to the lower part of the drawing, roughly locating the right fin.

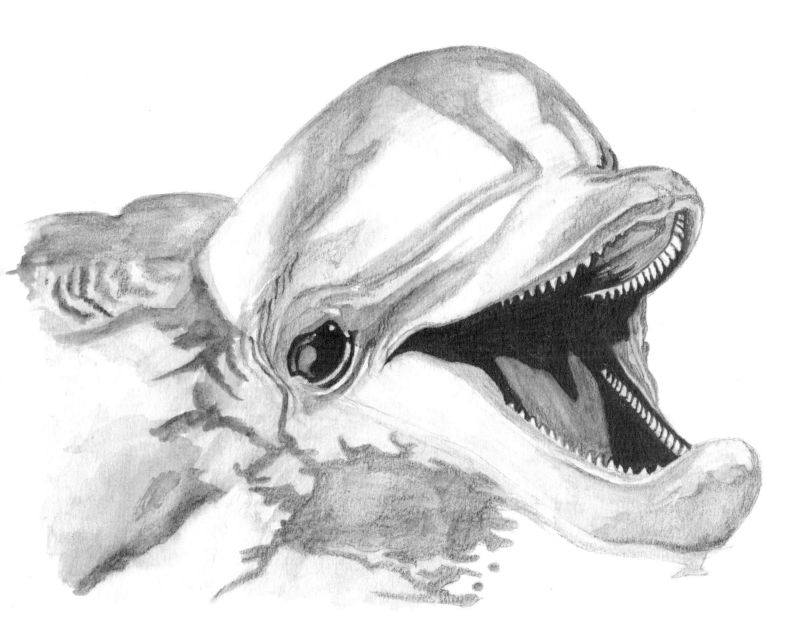

STEP 5

The final stage of the drawing involved applying a unifying liberal wash to the submerged part of the dolphin. This really enhances the blurry indistinct shapes of the body underneath the water.

BORDER TERRIER: DENSE TEXTURE

The relationship started on a practical level of codependence: the dog helped the human to hunt, in return for warmth, protection and a share of the food. Nowadays most people keep dogs simply for pleasure, but dogs still perform invaluable roles such as assistance dogs for the blind and deaf, sheepdogs and rescue dogs.

Our close relationship with dogs makes them wonderful animals to draw. Even if you don't have your own pet dog you only have to go for a short walk in a park to see a huge variety of canine subjects. The border terrier, with its stocky little legs and stiff beard, is one of many breeds that makes an enjoyable subject. It is the robust texture of the terrier's thick, wiry coat that I wanted to investigate in this project.

You will need

300gsm (140lb) cartridge paper

HB pencil

2B watersoluble pencil

8B watersoluble pencil

round watercolour brush (size 4)

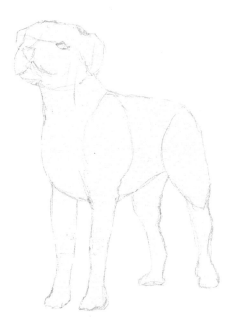

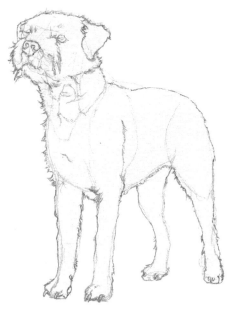

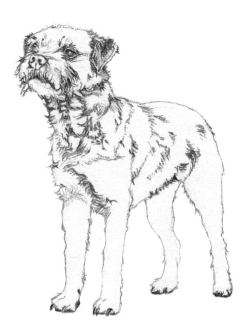

STEP 1

I used an HB pencil to roughly sketch the outline of the dog. At this early stage there was no need to think about detail, only to make sure the form was proportionally correct. I used search lines on the face to help me place the eyes and nose.

STEP 2

Once I was happy with the general form of the dog, I used a softer 2B pencil to draw the detail of the face and add texture to the outline.

STEP 3

Using an 8B watersoluble pencil, I began to shade the darkest areas of the face and body. I made sure I left a clear white highlight on the surface of the eye as this really brings the dog's expression alive. Sketchy areas of shade on the body not only evoke the texture of the fur but also help to suggest the solid form of the dog.

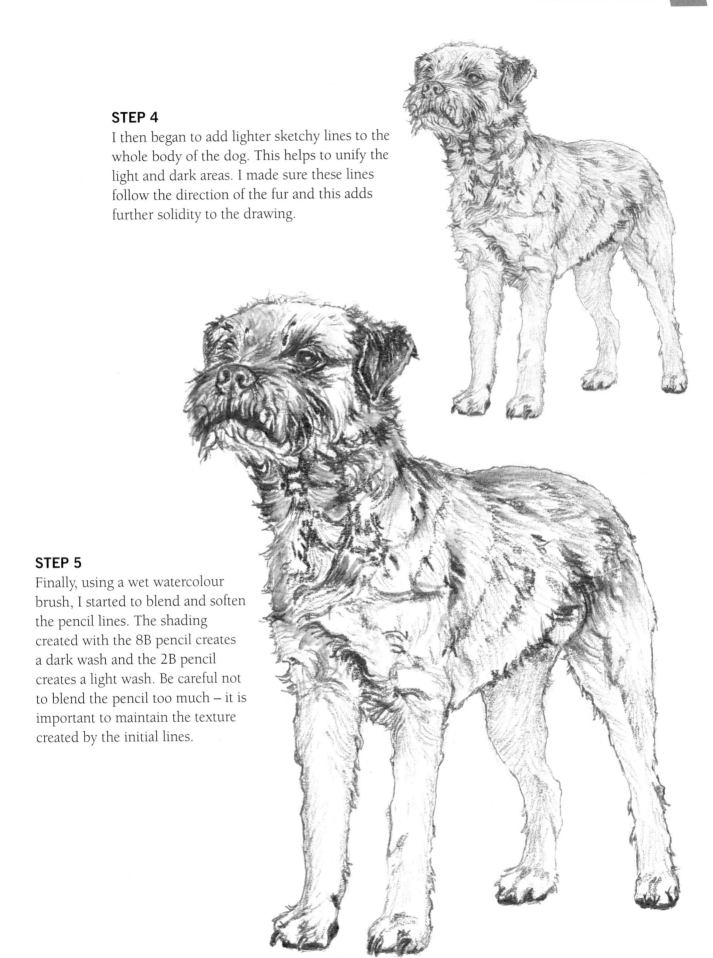

STEP 4

I then began to add lighter sketchy lines to the whole body of the dog. This helps to unify the light and dark areas. I made sure these lines follow the direction of the fur and this adds further solidity to the drawing.

STEP 5

Finally, using a wet watercolour brush, I started to blend and soften the pencil lines. The shading created with the 8B pencil creates a dark wash and the 2B pencil creates a light wash. Be careful not to blend the pencil too much – it is important to maintain the texture created by the initial lines.

Using Watercolours

Watercolours can be purchased in small hard block form, known as pans, or as liquid pigment, in tubes. Both are soluble when mixed with water. Making a dilute paint solution allows you to create transparent glazes. Pigment-heavy paint solutions are good for painting outlines, describing small detailed features and blocking in areas of opaque tone.

BRUSHES

Brushes are available in a variety of shapes and sizes and it is a good idea to have a range in your art box. Round brushes are very versatile. The bristles taper to a point so that the brush can be used to execute fine detail. The swell at the base of the brush means that it can hold a surprisingly large amount of paint and so can also be used for washes.

Flat brushes come in a variety of widths; wide flat brushes can block in a large area of base wash with only a few sweeps across the paper. Chisels are similar to flat brushes except that the end of the bristles is cut at an angle. They are available in a variety of widths and can be used for blocking in washes and also executing detail. For blending and also leaving bristle textures on the surface of the paper, the fan shape is ideal.

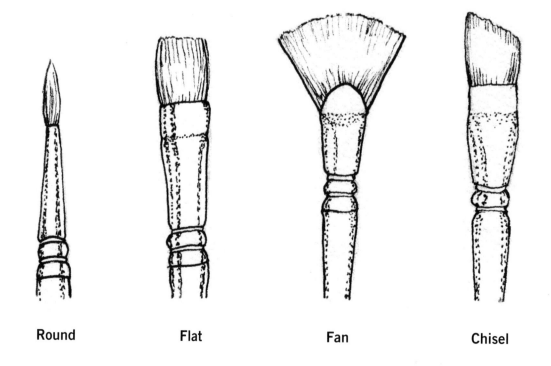

| Round | Flat | Fan | Chisel |

WATERCOLOUR TECHNIQUES

FLAT WASH

The wash is the most basic skill in the use of watercolour. Practise applying washes to a spare piece of paper. A wide flat brush is good for achieving a smooth, even application of unvarying colour, known as a flat wash.

GRADED WASH

This refers to the gradual dilution of pigment over the washed area to achieve a gradation of tone from dark to light. Start by applying a pigment-heavy brush stroke to the paper, then dip your brush in clean water and gradually draw out the pigment from this initial stroke.

GLAZED WASH

This technique allows you to create multi-layered tones. It is most effective when you are using colour but can also add depth when transparent monochromatic glazes are laid over one another.

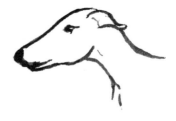

WET-ON-WET

This can produce some excitingly free and unexpected results. Wet your paper with a flat brush and add your paint to this wet surface. You can achieve some beautiful gradations as the paint spreads.

DRY BRUSH

Make up a pigment-heavy solution with a very small amount of water. Using a round brush, you can achieve fine detail. The technique is very controlled and precise.

LIFTING OFF

The beauty of lifting off is that it can be done when the paint is either wet or dry to create highlights. Simply use a damp brush to gently remove pre-applied pigment from the paper.

TABBY CAT: CREATING PATTERN

Cats are certainly more independent than dogs but they are wonderfully loyal and loving companions. They have various colours and lengths of fur, depending on the breed. The markings on a tabby's coat are a great subject to tackle when you want to experiment with creating a pattern.

You will need

300gsm (140lb) watercolour paper

HB propelling pencil

black watercolour pan

round (size 4) and flat (3/16") brushes

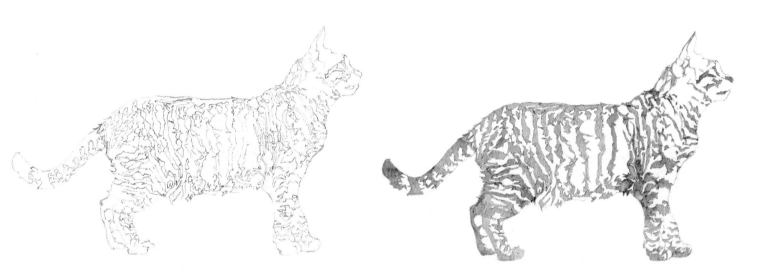

STEP 1

Using an HB propelling pencil, I started to draw the outline of the standing cat. I began by lightly drawing a straight line along the lower edge of the page so that I could be sure of drawing all four feet in the right location.

STEP 2

The key to this drawing was the creation of pattern, so I took time to draw in the outline of the stripes which characterize the tabby cat. These markings not only add variation and texture to the body of the cat, they also begin to bring solidity to the form. They act as cross-contour lines which, as we have seen, are a great way to evoke three dimensions.

STEP 3

Next I mixed a light transparent wash using plenty of water and several dabs of the black watercolour cube. I applied this solution to the stripe outlines that I had drawn in the previous stage.

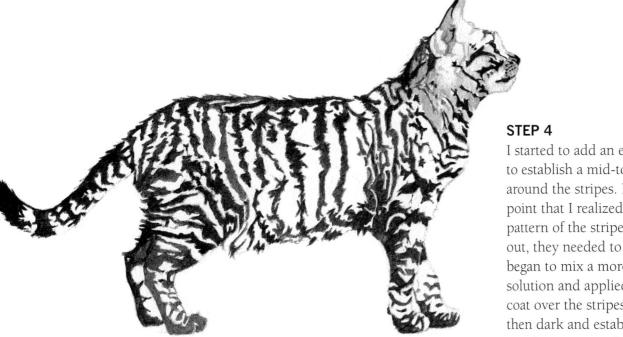

STEP 4

I started to add an even lighter wash to establish a mid-tone on the areas around the stripes. It was at this point that I realized that, for the pattern of the stripes to really stand out, they needed to be darker. I then began to mix a more pigment-heavy solution and applied this as a second coat over the stripes. The pattern was then dark and established enough to stand out against the mid-tone.

STEP 5

I extended the mid-tone wash across the body of the cat using the flat brush. I used rough brush strokes to evoke the texture of the cat's fur around the central edges of the body and left the white of the paper exposed on the side of the cat. This three-levelled variation of tone allows the pattern to maintain its clarity while at the same time paying attention to the more subtle shadows which describe the form and furry texture of the cat.

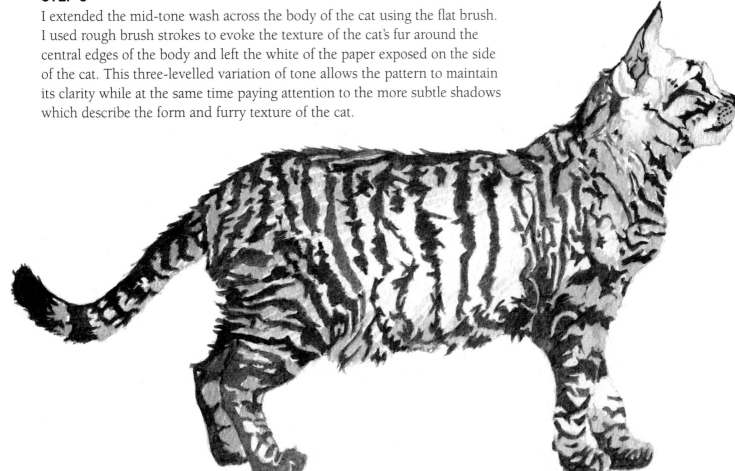

Pen and Ink

Most of the same techniques that we have looked at when working with a pencil can be used with pen and ink. These spheres show how different applications of the ink have been used to give the circular outline substance.

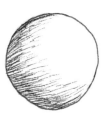 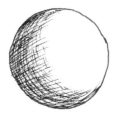 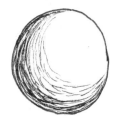

| Hatching | Crosshatching | Contour hatching | Stippling | Scumbling | Opaque inking |

The beauty of pen and ink is the clear detail that can be achieved when you use a fineliner pen and by contrast the bold graphic statements which can be created with thick markers and brush pens. The next two step-by-step examples will show these two very different styles that you can achieve with pen and ink techniques.

PANDA: BOLD GRAPHIC STYLE

Think of a panda and you automatically think of black and white. This makes the panda a perfect subject to demonstrate a graphic high-contrast style like a cartoon. I wanted to keep this picture very simple, with very little descriptive detail so that the bold extremes of tone are allowed to speak for themselves.

You will need

160gsm (98lb) cartridge paper

HB propelling pencil

0.3mm pigment liner

0.5 felt pen

brush pen

STEP 1

Using an HB propelling pencil I drew in the outline of the panda, adding lines to demarcate the divisions between the black and white areas of fur.

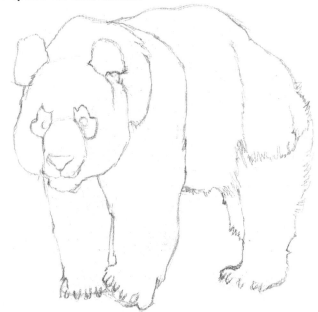

STEP 2

I used a 0.3mm black pigment liner to draw over my pencil outline. Then, with a 0.5mm felt pen, I went over the outlines surrounding the black areas.

STEP 3

Taking my brush pen, I began to block in the black areas, starting with the eye and ear patches.

STEP 4

I inked in the rest of the panda's black patches, going over places where the black of the ink was not quite intense enough – I wanted to create a real opaqueness of black to heighten the contrast with the white of the paper. Finally I made sure to leave a broken white line between the front and back legs and white highlights to show the location of the toenails.

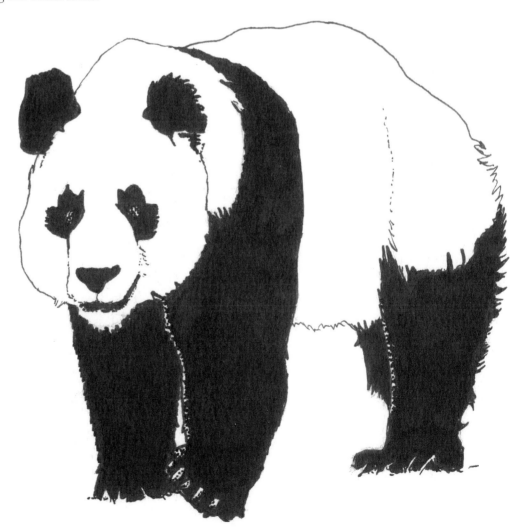

PORCUPINE: FINE DETAIL

Porcupines are rodents, just like mice and gerbils – what makes them distinctive is their famously long, sharp spines. These make a porcupine the perfect subject to demonstrate the clear detail that can be achieved using fine-nibbed ink pens.

You will need

160gsm (98lb) cartridge paper

HB propelling pencil

0.3mm pigment liner

STEP 1

Using an HB propelling pencil, I began by drawing the rounded familiar rodent head of the porcupine. I then started to add an array of long pointed spines sprouting from the base of the neck and extending backwards to form the outline of the animal's back. Beneath this spiky upper outline I drew in the short legs and rounded paws.

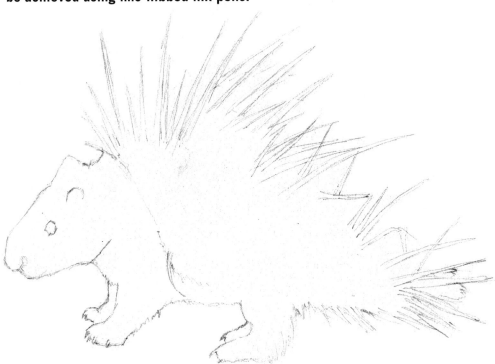

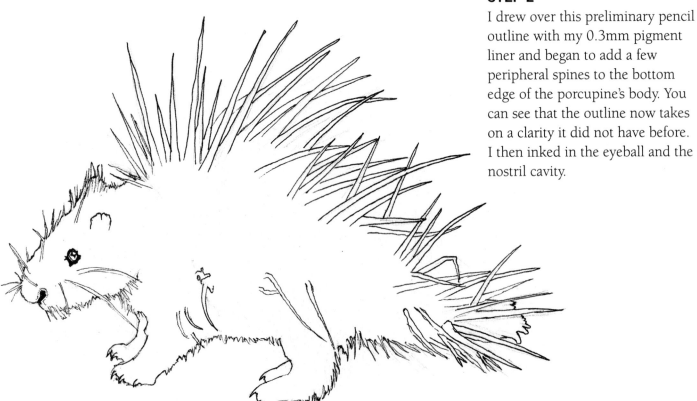

STEP 2

I drew over this preliminary pencil outline with my 0.3mm pigment liner and began to add a few peripheral spines to the bottom edge of the porcupine's body. You can see that the outline now takes on a clarity it did not have before. I then inked in the eyeball and the nostril cavity.

STEP 3

I worked methodically, covering the back in spines, making sure they mainly went in the same direction but adding the odd crossed spine to add variety and visual interest. This process was quite time-consuming but well worth the effort. I began to put in a few small spikes around the perimeter of the mass of long spines and then started to add stippling to the face for surface texture. I then began to add dark marking to the spines; this gives them further prominence.

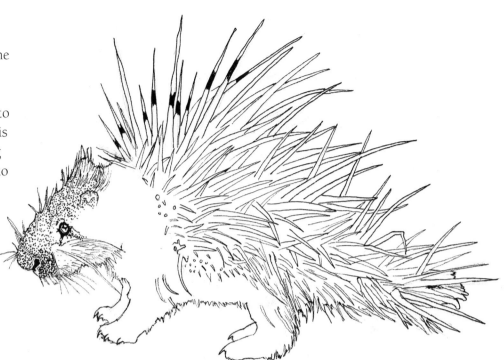

STEP 4

I added further markings to the spines then, to finish the drawing, I used small hatched lines to act as a textural bridge between the fine stippling on the face and the bold statement of the spines. The overall effect is one of textural contrast, effectively rendered by the versatility of the pen and ink technique.

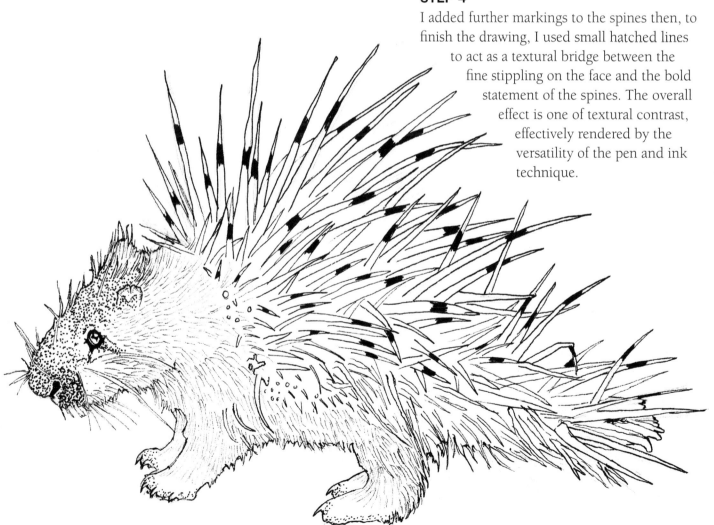

Charcoal and Chalk

Charcoal can be used in much the same way as pencil, so there are no tricky techniques to master. Its dark intensity makes it a great medium for creating smoky, dramatic drawings with heightened tonal contrast. You can use white chalk to add highlights to your charcoal drawings. Charcoal is available in several forms:

WILLOW CHARCOAL is charcoal in its rawest form, made by charring sticks of willow. This charcoal is very soft and brittle and can be used to add really subtle gradations of tone.

COMPRESSED CHARCOAL comes in the form of hard sticks which can create intense dark tones.

CHARCOAL PENCILS are great because they can be sharpened and applied to the paper like a pencil. They are capable of delineating fine detail.

You will find your tortillon a very useful tool for blending charcoal marks to give the tone a smooth quality. It's advisable to use a paper with a textured surface so that the granules of charcoal have something to attach to. To preserve your drawings and prevent smudging you will need to apply a fixative to your finished work. A strong hairspray is a very effective fixative but in time may discolour, so for work you are really pleased with it's best to buy a fixative designed for the job.

MOOSE: DRAMATIC LIGHTING

The moose is the largest member of the deer family, recognizable by the magnificent crown of rounded antlers. Moose are solitary creatures and only come together to mate. It is this strong, mysterious solitude that I wanted to convey in my study. I concentrated on my portrayal of light and shadow, at times layering shadows to add depth to the image. I was aiming for a chiaroscuro effect, a term used since the Italian Renaissance to mean strong contrast between dark and light.

You will need

160gsm (98lb) fine-grain
 cartridge paper

HB propelling pencil

charcoal pencil

tortillon

white chalk

STEP 1

I wanted the antlers to be the main focus of this picture, so I started by drawing the head and humped back of the moose and then, using this base form to work from, accentuated the relative size of the antlers. Next I added the outline of the legs and began plotting the position of the cast shadows. For these preliminary outlines I used an HB propelling pencil.

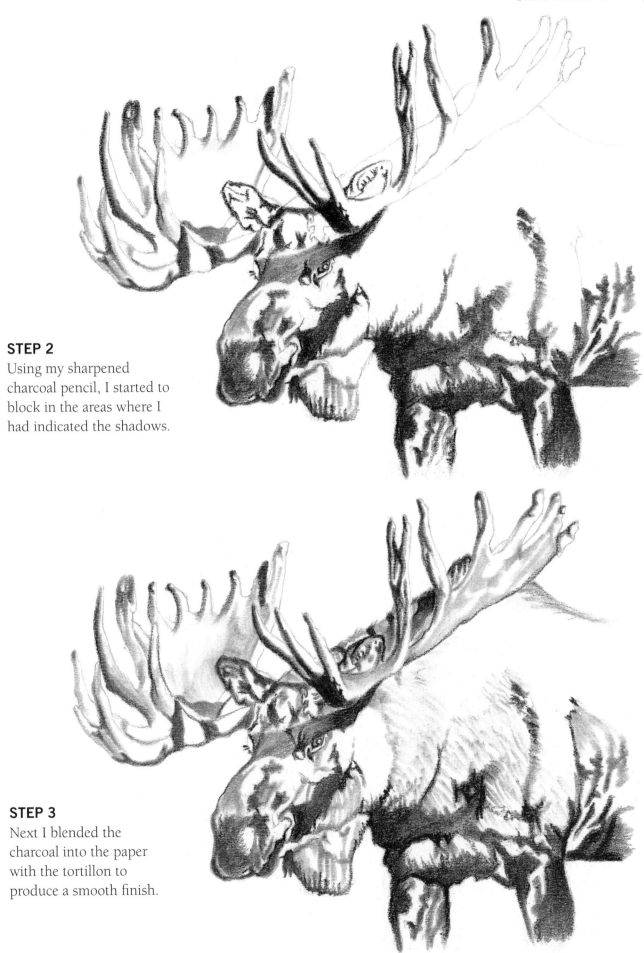

STEP 2
Using my sharpened
charcoal pencil, I started to
block in the areas where I
had indicated the shadows.

STEP 3
Next I blended the
charcoal into the paper
with the tortillon to
produce a smooth finish.

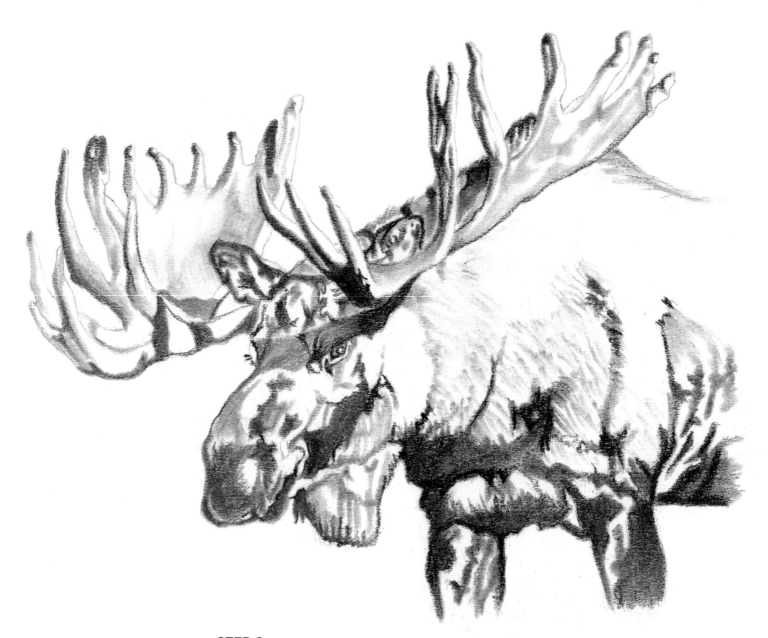

STEP 3

I used the excess charcoal that had adhered to the tortillon to add smooth, soft, smudgy shadows to the antlers. Then, still using the tortillon, I put in a succession of quick movements to add fur-like texture to the areas of the body closest to the shadow detail. I also started to darken the most intense areas of shadow underneath the foremost antler and the facial detail within this cast shadow. This really adds depth to the picture.

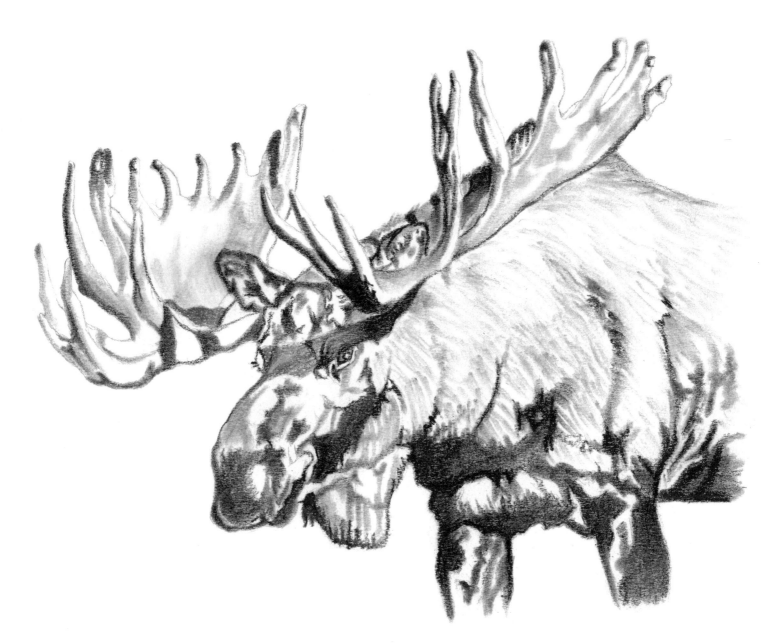

STEP 4

Finally I began to introduce a textured mid-tone over the
upper part of the moose's body. Firstly I scumbled the
white chalk into the paper and then used the tortillon to
smudge in soft hatched lines; these lines emphasize the
texture of the moose's fur and help to express the solid
curves of the three-dimensional form.

Soft Pastel

Soft pastels are made up of pure pigment held together with a gum binder. Pastels can be used in much the same way as pencils to execute hatched and crosshatched lines and stippled effects. Their big advantage is their ability to achieve soft gradated tone because they are easily blended. They can produce wonderful sfumato effects – an Italian term which means 'to evaporate like smoke'. This diffuse tonal gradation is fantastic for creating subtle and sensitive representations of shade and texture.

As with charcoal, it's a good idea to use a grained paper when working with pastels to give the pigment something to adhere to. Fixative is also important to preserve your pastel drawings.

KOALA AND BABY: SOFT TEXTURE

Koalas, like wombats and kangaroos, are Australian marsupials, meaning that they give birth to their young after a very short gestation and the development process continues outside the womb in a protective pouch. They spend most of their time in the branches of the eucalyptus trees which are their main source of food. The koala is a great subject to depict with soft pastel; the soft, fluffy grey fur can be evoked perfectly with this subtle medium.

You will need

160gsm (98lb) fine-grain paper

HB propelling pencil

black, white and grey soft

 pastels

tortillon

STEP 1
First I sketched the outline of the mother and baby with an HB propelling pencil. Their forms are framed and supported by the V-shape of the tree branches upon which they sit.

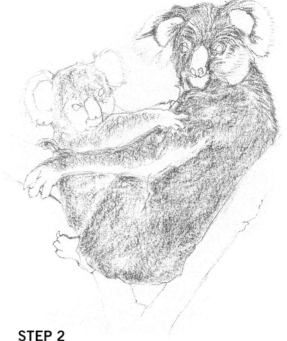

STEP 2
Using a mid-grey pastel, I blocked in a base 'ground' of tone on to the bodies of the pair.

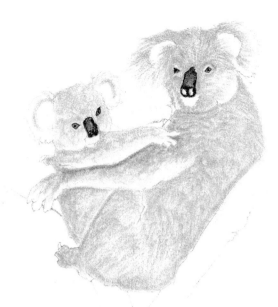

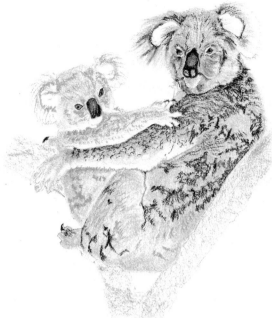

STEP 3

Taking the tortillon, I blended the ground into a smooth surface, leaving the white of the paper exposed on the underside of the arms. I began to feather the grey ground around the ears to start to suggest the fluffiness of the fur. Next I used a black pastel to darken the koalas' eyes and noses.

STEP 4

Still using the black pastel, I started to add textural detail to the body of the mother. Then, using a white pastel, I added highlights to the rims of the eyes to heighten the intensity of their gaze. Next I roughly blocked in a ground upon the trunk of the tree using a mid-grey pastel.

STEP 5

I blended the black texture detail on the bodies to soften the overall textural appearance and added a few white highlights amid the black. I then added some black lines to the trunk of the tree to evoke the bark texture. I then realized that the composition looked rather precarious, so I decided to add another straight tree trunk behind the mother koala. This final addition gives the composition stability and strength.

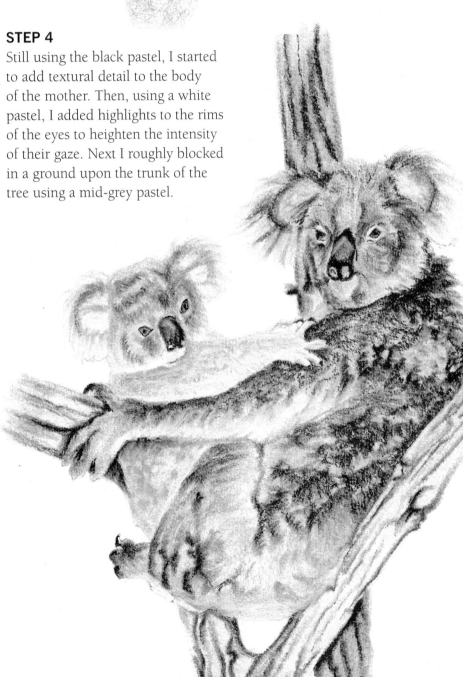

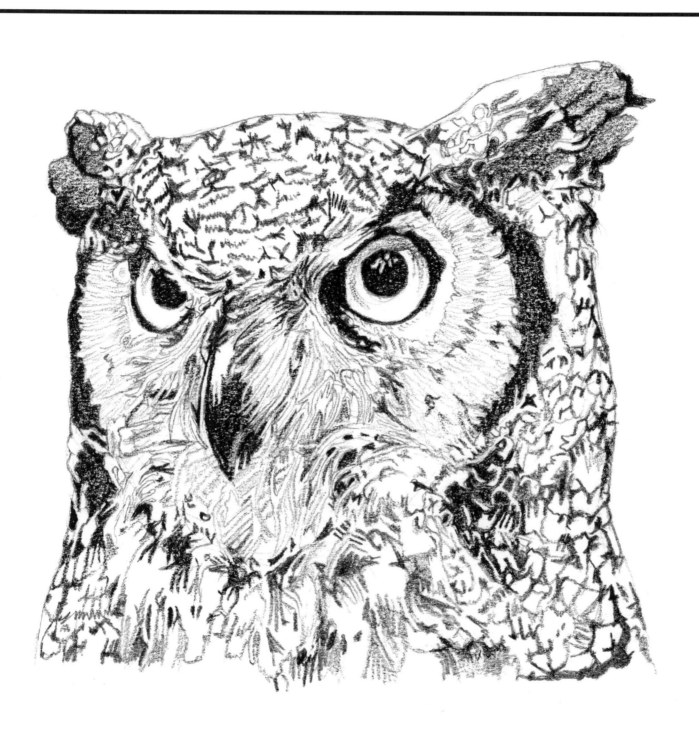

Chapter 3

ANIMAL PORTRAITS

Portraiture is one of the oldest disciplines in art, for until the arrival of photography it was the only way in which people could preserve their image for posterity. Achieving an accurate likeness was therefore an extremely important skill for the artist, along with conveying the personality of the sitter – though of course there was often a need for the artist to flatter in order to be paid his fee when the portrait was completed.

In this chapter we shall examine how to draw animal faces so that they not only appear as accurate representations of the subjects but also express the emotions that make animals such an engaging subject to draw. Fortunately, you don't also need to worry about pleasing your models!

Drawing the Features

The facial features of animals vary greatly because they have evolved over time into the best form to suit the survival needs and habitat of each species. Look at a picture of an animal's face and you will instantly know what type of animal it is, since the characteristic components and proportional relationships make it recognizable. It is observing how the eyes, nose and mouth are placed that will help you to create anatomically accurate and beautiful animal portraits. The human brain has an amazing ability to pick up on the tiny details which identify a face, so changing one of these even slightly will make your drawing look unconvincing.

FULL-FACE PORTRAITS

One of the most important things you will notice about any animal's face, when viewed from the front, is its symmetry – eyes which are located at the same height, a nose or beak right in the middle and a mouth directly beneath. Obviously there is huge variety in the form of these features, but as a rule of thumb bilateral symmetry is a feature of almost every face.

A good way to begin drawing a face is to start with a rough circle and draw a line down the centre horizontally and vertically. This will allow you to position the eyes on the same level and the nose in the centre, so you can then plot the location of the mouth in relation to these features.

Here you can see how I have used this method. I have simplified a variety of faces to their basic structure and proportional relationship so that starting your adventures into portraiture will become less daunting. Once you have seen how every face can be pared down to its basic ingredients, you will start to look at new subjects in a similar way and be able to begin by getting the structural foundations of the face right first before you move on to the detail of texture and tone.

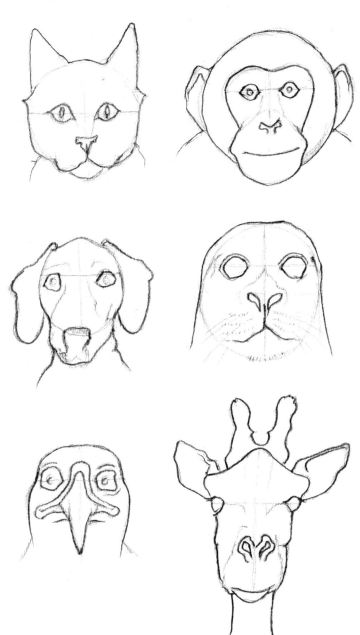

THREE-QUARTER PORTRAITS

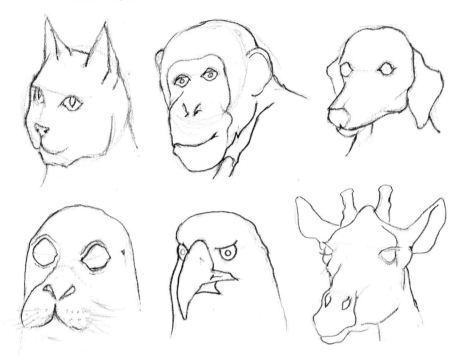

Once you feel confident about making simple sketches of animal faces seen from the front, it's time to start experimenting with different views. The three-quarter portrait, which shows the face slightly turned away from the viewer, is popular as it's a less confrontational way of showing the face; you can still depict the whole expression without the intense frontal stare of the eyes, which allows you to create more sensitive portraits. It is a little more complicated than frontal representation because you cannot rely on symmetry within a circle to help you plan your drawing. However, some practice at drawing a face from the front will have given you a familiarity with the features and this will allow you to tackle the same face from a three-quarter viewpoint without too much difficulty.

PROFILE PORTRAITS

This type of portrait was used commonly on Greek and Roman medallions and to depict rich and important people in paintings. It is a very regal, aloof style of portrait, where there is very little communication established between subject and viewer. It is slightly easier to draw a profile than a three-quarter portrait as you don't have to take into account the recession of the face. I started each portrait by drawing a rough circle. Starting with a simple shape allows you to establish the size and rough spherical shape of the head to which you can then add more detailed outlines. Look carefully at your subject while you are drawing to achieve a clear and accurate outline for your profile.

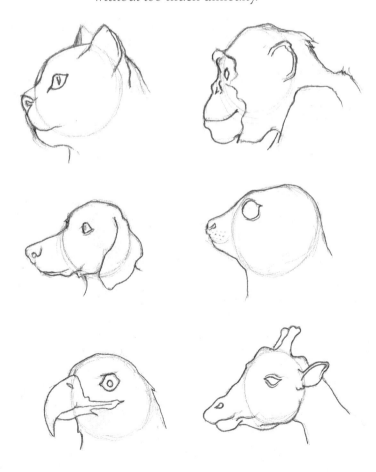

Conveying Emotion

Animals' faces convey just as much emotion as the human face; we can recognize an animal expression in the same way that we read the face of a person. I made these sketches of a cat, meerkat, dog and bear. You should have no difficulty in identifying which of them is sleepy, aggressive, scared or alert.

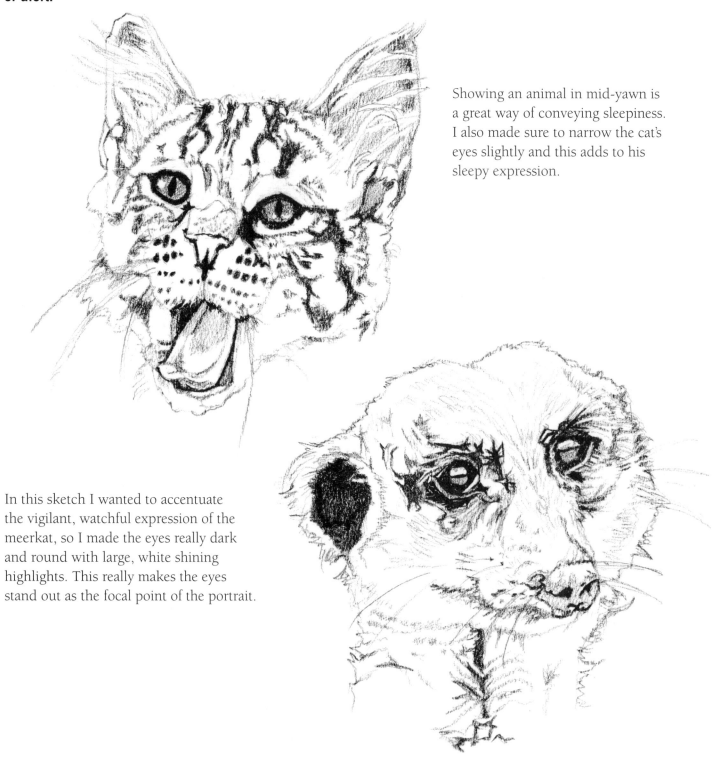

Showing an animal in mid-yawn is a great way of conveying sleepiness. I also made sure to narrow the cat's eyes slightly and this adds to his sleepy expression.

In this sketch I wanted to accentuate the vigilant, watchful expression of the meerkat, so I made the eyes really dark and round with large, white shining highlights. This really makes the eyes stand out as the focal point of the portrait.

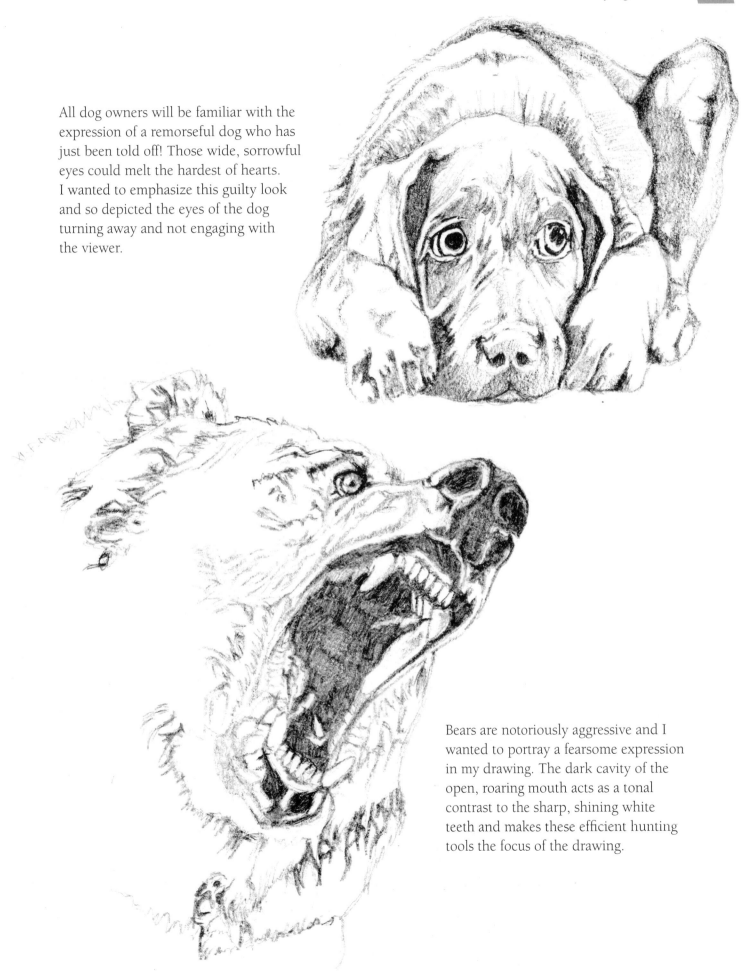

All dog owners will be familiar with the expression of a remorseful dog who has just been told off! Those wide, sorrowful eyes could melt the hardest of hearts. I wanted to emphasize this guilty look and so depicted the eyes of the dog turning away and not engaging with the viewer.

Bears are notoriously aggressive and I wanted to portray a fearsome expression in my drawing. The dark cavity of the open, roaring mouth acts as a tonal contrast to the sharp, shining white teeth and makes these efficient hunting tools the focus of the drawing.

Lion

The male lion is well known for its impressive full mane and it was this that I wanted to exaggerate in my portrait. I chose to execute this portrait in soft pastel because it is easy to blend into soft textural and gradated tone, perfect for evoking the lion's shaggy fur. We have all seen the concentrated stare of the lion as it stalks its prey on wildlife programmes and I decided on a full-face portrait to capture this intensity of gaze.

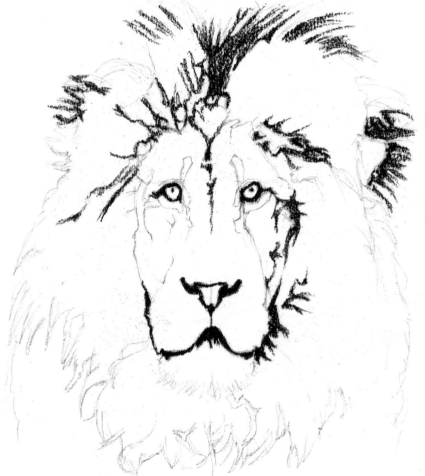

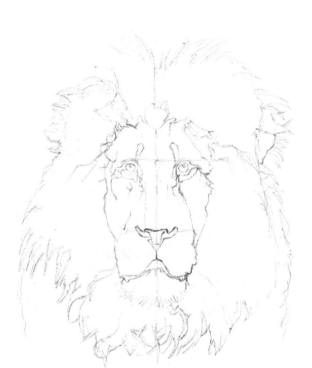

STEP 1

I started by drawing a rough elongated oval with an HB pencil and divided it vertically through the middle with a light pencil mark. This vertical line helped me to allocate the features between the two halves of the face and establish their symmetry. Next I drew a horizontal line through the top and bottom half of the oval as guides for the position of the eyes and nose. I was then able to add the mouth in relation to the nose. I refined the lines around the face and added numerous rough sketchy lines to denote the full and fluffy mane.

STEP 2

I looked at my reference photograph through half-closed eyes, which is a good way of eliminating complicated detail that you don't need to worry yourself with at this stage. It also helps you to establish the main tonal contrasts in the image. Using my black pastel stick, I began to shade in the darkest areas of the face and mane.

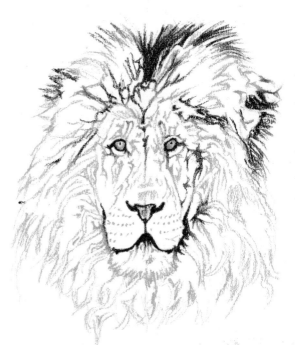

STEP 3
Using a grey pastel stick, I started to add a mid-tone to the drawing. This stage also establishes the soft, shaggy texture of the lion's fur.

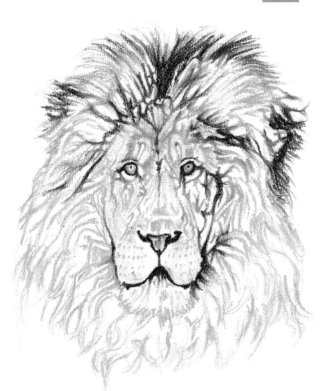

STEP 4
I then began to blend and soften the dark and mid-tone into each other, using a tortillon. I blended the grey pastel detail on the surface of the face so that it appeared really smooth to serve as a contrast with the rougher texture of the lion's mane.

STEP 5
Taking the black pastel, I began to add some more shadows to the mane to exaggerate the texture of the surface. Finally, I darkened the lines around the perimeter of the face so that it stands out from the mane, adding to the dramatic impact of the final image.

Chimpanzee

Chimpanzees are one of our closest cousins in the animal kingdom and this relationship is very clear in their physical similarities to humans. Their faces are largely the same as ours, with a few proportional differences. It was this humanity of expression that I wanted to capture in my drawing, for which I felt a full-face portrait would be best. Chimps are well known for their deep black fur, so I chose to use charcoal to create this portrait.

You will need

160gsm (98lb) fine-grain
 cartridge paper
HB propelling pencil
charcoal pencil
tortillon

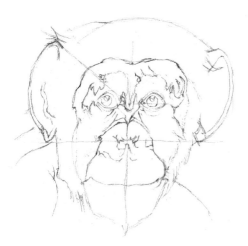

STEP 1

I began by lightly sketching a rough circle with an HB pencil and as before used horizontal and vertical lines to help me accurately locate the eyes, nose and mouth. I sketched a diagonal line from the left eye upwards to the left of the face as an aid to where the top of the ear should go. The horizontal line which I had used to plot the placing of the nose also acted as a guide to where I should draw in the bottom of the ear. I was then able to draw in the opposite ear using the same upper and lower parameters.

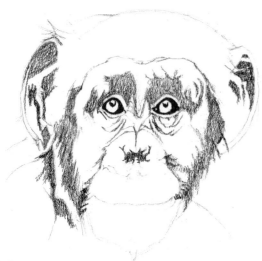

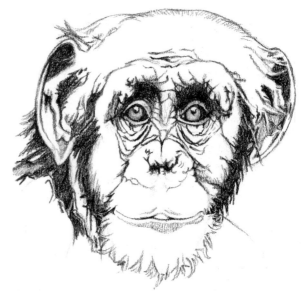

STEP 2

Using a charcoal pencil with a rounded point, I began to lightly shade in the darkest areas of the face. I then sharpened the pencil and used a firm pressure to apply the charcoal to the area around the eyeballs. I wanted these to be the darkest features of the portrait so that the eyes stood out to become the main focus for the viewer.

STEP 3

Making sure my charcoal pencil was sharp, I began to add lines to suggest the wrinkles around the eyes. I then darkened the shadows I had marked out in the first step. Using my tortillon, I smudged a grey mid-tone on to the eyeballs, making sure I retained a white highlight above the pupil. With these darkest tones established, I then began to think about texture and started to add rough sketchy lines to the chin and top and sides of the head.

STEP 4

I took the tortillon and began to blend the shadows on the cheeks. I then smudged lines on to the top of the head to show the texture of the hair and also to establish the curve of the cranium.

STEP 5

I added further light shadow to the bottom half of the face, using the tortillon. I then used the charcoal pencil to add light, furry texture to the chin. Finally I shaded the chest and shoulders, focusing particularly on darkening the area beneath the chin. This produces a contrast which throws the face into focus and really makes the expression engage with the viewer.

Red Setter

You will need

300gsm (140lb) watercolour
 paper

HB propelling pencil

black watercolour pan

round watercolour brush (size 4)

In this portrait I wanted to evoke that loyal gaze that every dog owner will know. The red or Irish setter has beautiful wavy, silken fur and large, soft eyes. It is a highly intelligent dog that forms very close bonds with humans, so the expression of devotion and the unique texture of the fur were the two main elements I wanted to capture. I chose an angle between a profile and a three-quarter view that allows the beautiful elongated shape of the muzzle to be shown and also exposes a large surface area of the dog's coat. I decided to use watercolour to make this portrait; the fluidity and spontaneity of the medium, I felt, would perfectly evoke the setter's fur.

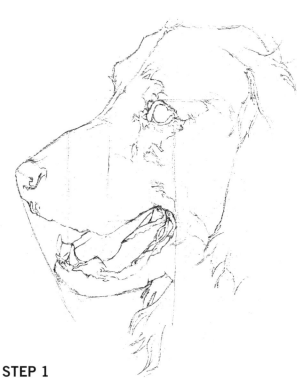

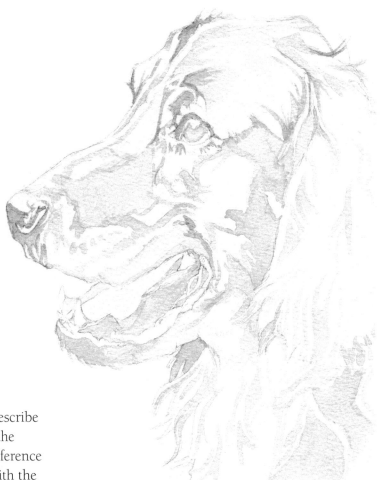

STEP 1

Using an HB pencil, I began by drawing the line to describe the top of the head, letting it softly curve down into the brow and bridge of the muzzle. Checking with my reference photograph, I saw that the top of the eye was level with the bottom of the eyebrow, which curves into a pyramid shape. I drew a horizontal line from this point and this helped me draw in the eye. I drew a vertical line downwards from the outer corner of the eye and this enabled me to locate the corner of the mouth. A diagonal line drawn downwards from the tip of the nose located the end of the lower jaw. Having established these main facial features correctly, I added some sketchy lines to evoke the fur of the ear and chest.

STEP 2

Using the black watercolour pan, I mixed a very dilute paint solution and applied it to the paper using loose brush strokes. This light tone established a perfect base upon which to work up darker tone and texture.

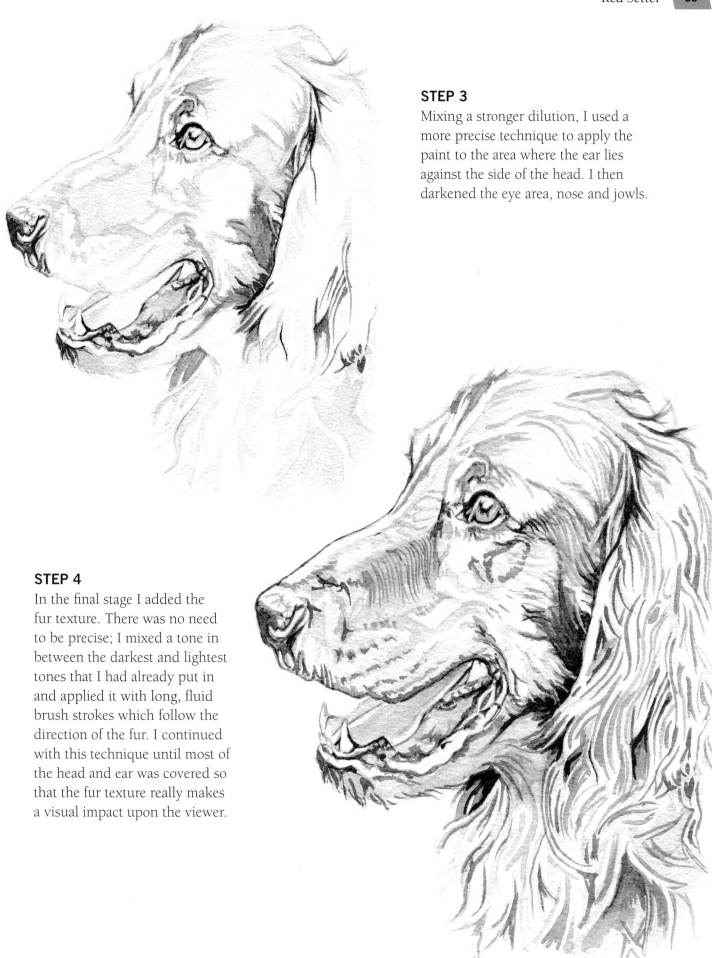

STEP 3

Mixing a stronger dilution, I used a more precise technique to apply the paint to the area where the ear lies against the side of the head. I then darkened the eye area, nose and jowls.

STEP 4

In the final stage I added the fur texture. There was no need to be precise; I mixed a tone in between the darkest and lightest tones that I had already put in and applied it with long, fluid brush strokes which follow the direction of the fur. I continued with this technique until most of the head and ear was covered so that the fur texture really makes a visual impact upon the viewer.

Great Horned Owl

This owl is a large predator, native to the USA. Its role as hunter has defined its appearance – huge, keenly sighted eyes to spot its prey, a large hooked beak with which to tear it apart and the long tufted horn-like feathers to accentuate the hearing so that the owl can detect the tiniest squeak of a mouse. I wanted to make a three-quarter portrait of the owl because I liked the way the dark feathers forming the 'horns' extend into eyebrows which converge diagonally into the centre of the face, framing the eyes and adding to their intensity. These dark diagonals, together with the dark circular perimeter framing the face, act as lines to guide the viewer to the intense stare of the large eyes.

You will need

300gsm (140lb) cartridge paper

HB propelling pencil

6B pencil

2B pencil

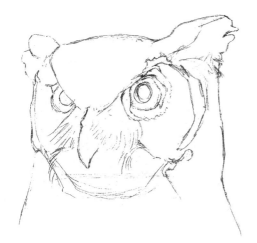

STEP 1

Using an HB pencil, I drew a rough square and this became the basic shape of the owl's head. Within this shape I drew an approximate circle which demarcates the front of the face. I added the triangular shapes to the corners of the outer shape to form the 'horns' and from these I drew two diagonal lines that converged in the centre of the circle. At the point of these diagonals I drew in the curved beak. Finally I added the eyes.

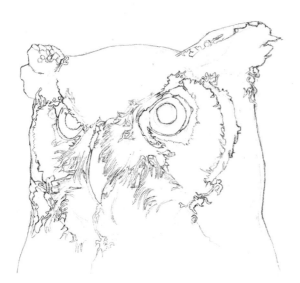

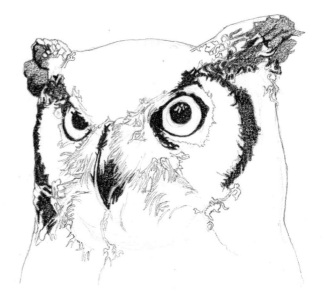

STEP 2

I used this step to refine the rough outlines which had been laid down in stage one, strengthening the outlines, correcting slight errors and adding texture and variation.

STEP 3

With the 6B pencil I shaded the darkest areas of the owl – the pupils and rims of the eyes, the beak, the circle framing the face and the diagonals extending from the 'horns'.

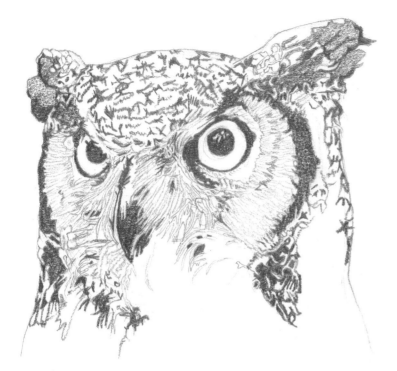

STEP 4

This was the most laborious stage of the drawing, requiring a lot of concentration and reference to my source image. With the 2B pencil I began by adding soft hatched lines to the centre of the face, radiating outwards. I then worked on the feather pattern on the top of the head using small scumbling motions with the point of the pencil. Eventually the regular pattern began to take shape, suggesting the texture of the feathers.

STEP 5

Finally, I added the remaining pattern detail to the lower half of the portrait to bring the face and the neck of the owl together into a cohesive form.

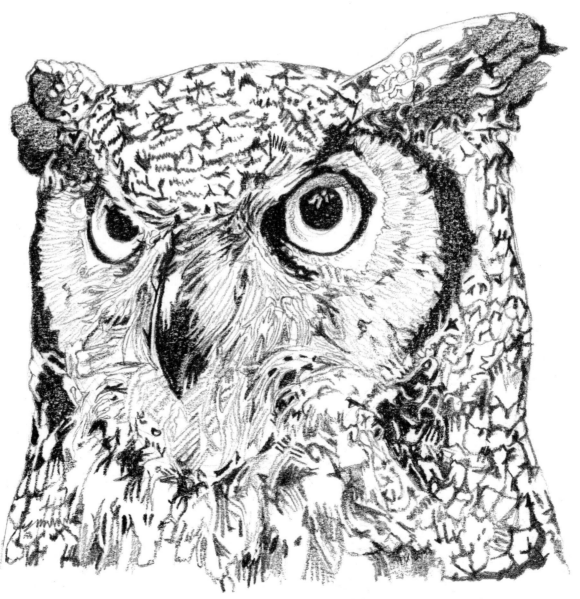

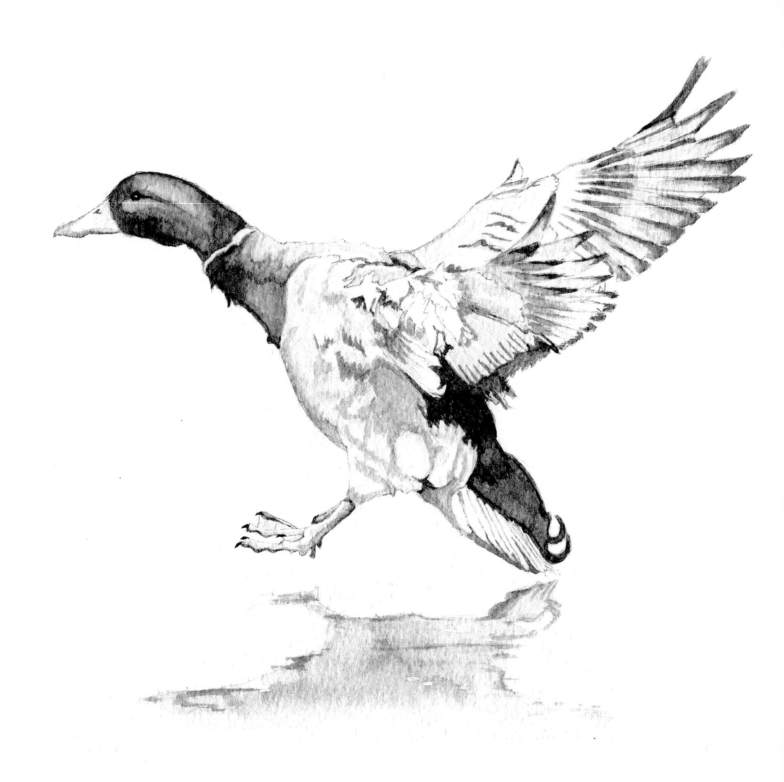

Chapter 4

CAPTURING MOVEMENT

The variety of forms within the animal kingdom is enormous
and therefore so is the variety of movements. However, don't let
this daunt you, for there are a few types of movement that are
found in most animals. In this chapter we shall examine them and
work through projects that will teach you how to show each type
of movement in your drawings. We shall explore how different
materials can heighten the power of the movement you are trying
to capture in your drawing and how placing your subject in a
context can accentuate movement. Adding a background, even
a few simple sketchy lines, can go a long way to suggesting what
your animal is doing.

Gesture Drawings

Before you start to think about creating finished, detailed works of animals in motion, familiarize yourself with a variety of moving forms by making very quick gestural sketches. Don't worry about getting every line right when you make these drawings – the exercise is about experimenting with line and learning what works and what doesn't. Each drawing should take only a minute or two. This type of quick sketching is perfect for recording the transient poses of a moving form. The exercise of gesture drawing will free you up and strengthen your familiarity with a form, giving you the foundations to build your more detailed drawings upon.

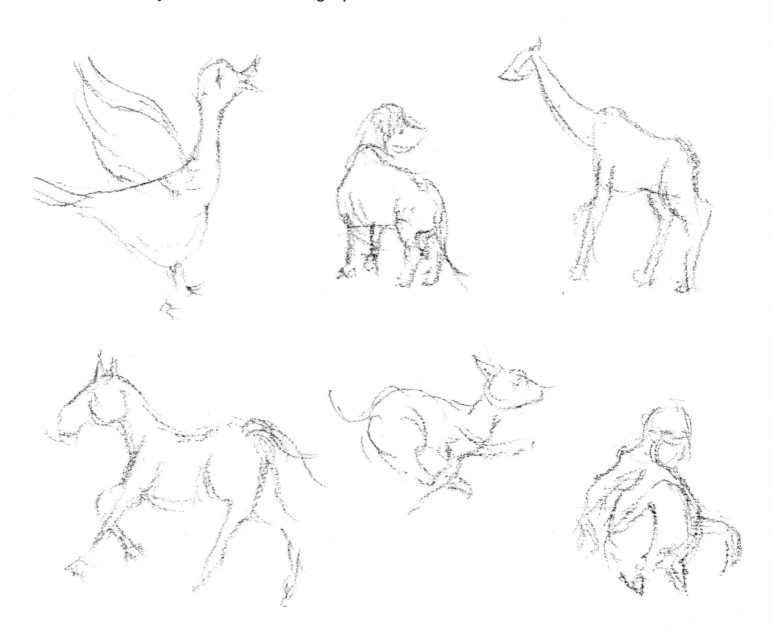

I did this sketch of a dog lying down in about a minute. I have added arrows showing the direction of the pencil on paper as I constructed the drawing. Try executing this sketch quickly yourself, following the arrows as you go. Having an idea of how you are going to tackle the lines which make up a form will help your confidence grow and allow you to create your sketches freely and quickly.

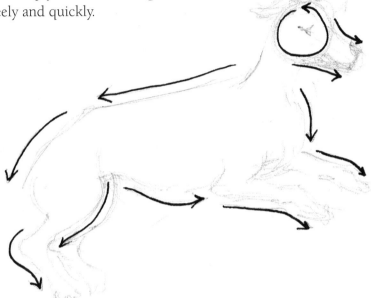

These drawings of a trotting dog and a rearing horse are a little more worked up. I started them as lightly drawn gesture drawings and then took some time to strengthen and clarify the outlines and emphasize the solidity and presence of each animal. I have added arrows to show the key movement and flow within the three-dimensional form.

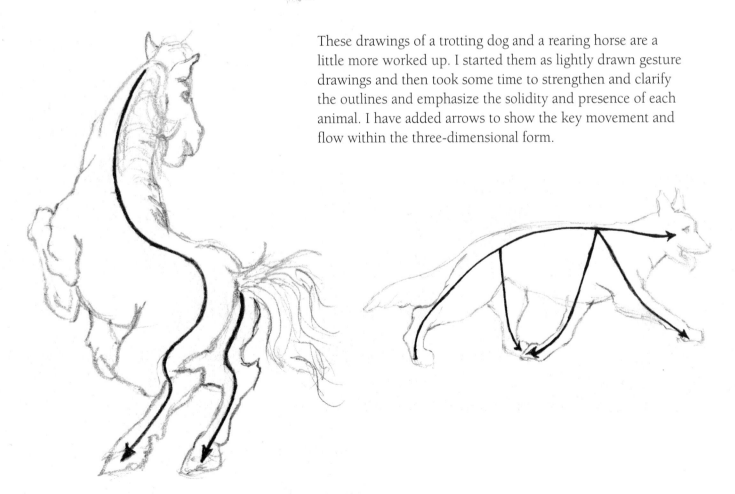

Cheetah

You will need

300gsm (140lb) cartridge paper

 (though lighter paper can be

 used)

HB propelling pencil

0.1mm black pigment liner

0.3mm black pigment liner

black felt pen

There are some animals whose beauty and spirit are best captured when they are moving, partly because their speed defines their character in our minds and also because their bodies are so evolved to achieving that speed that they are most impressive when exerted.

The fastest land mammal on the planet is the cheetah, which is slight of build and composed almost entirely of muscle and bone. This makes it an intriguing subject to draw, as you can clearly see the skeletal and muscular structure beneath the skin and short fur. I wanted to capture this slender muscular form as a means of conveying speed. My drawing shows the cheetah at an oblique angle, which adds to the dynamism of the body; the front legs are foreshortened while the back is lengthened, which accentuates the forward momentum of the animal.

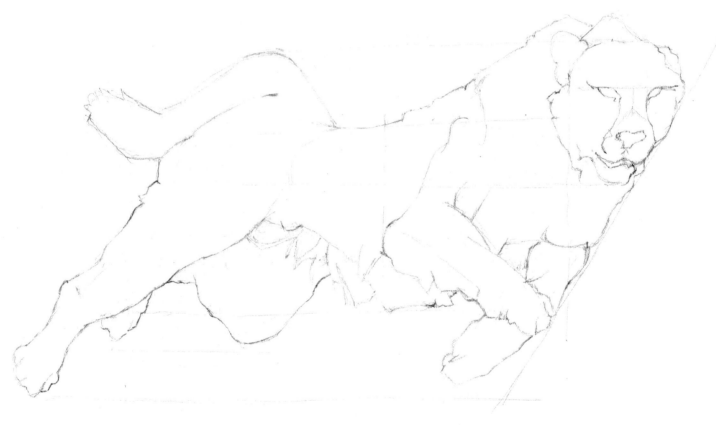

STEP 1

Using an HB propelling pencil, I began by drawing the undulating line of the cheetah's head, back and tail. I then used straight guidelines to help me create the rest of my outline. A diagonal drawn from the top right helped me to construct the front far side, while verticals and horizontals allowed me to plot the other key points of the body so that they related proportionally to each other. I referred constantly to my source image as I worked.

STEP 2

A cheetah wouldn't be a cheetah without its spots – their coat is probably their most distinctive and beautiful feature. Once I had erased all my guidelines, I began work on the spots. It took some time and concentration to follow the pattern and form of each one, but it was definitely worth the perseverance. The final pattern not only looks striking, it also helps to sculpt the three-dimensional surface of the body, accentuating the curves of the muscles.

STEP 3

Using a 0.3mm pigment liner, I drew over the pencil outline of the whole cheetah, which added clarity to the form. I then began to ink in the detail of the face.

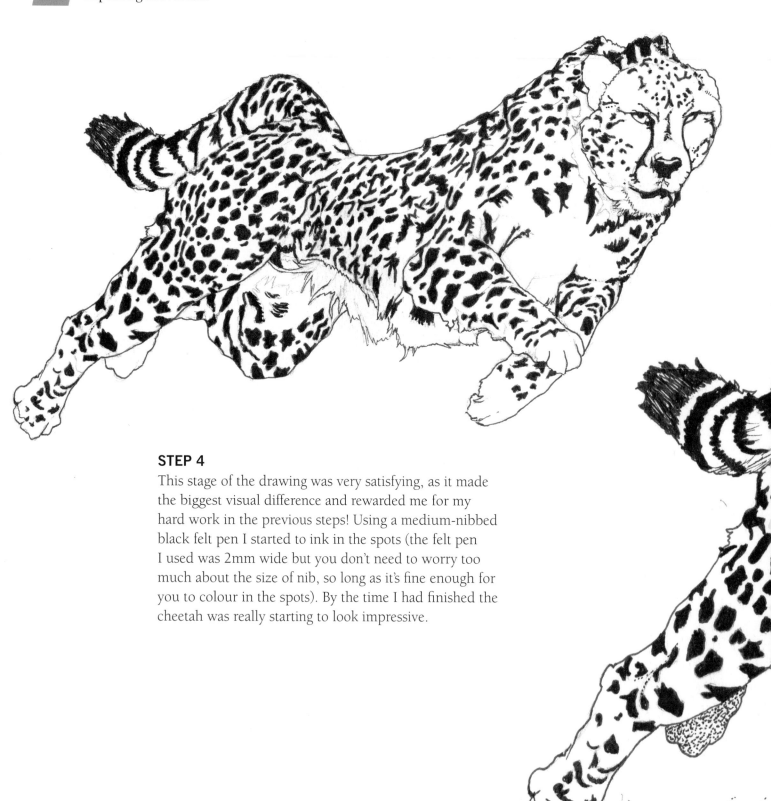

STEP 4

This stage of the drawing was very satisfying, as it made the biggest visual difference and rewarded me for my hard work in the previous steps! Using a medium-nibbed black felt pen I started to ink in the spots (the felt pen I used was 2mm wide but you don't need to worry too much about the size of nib, so long as it's fine enough for you to colour in the spots). By the time I had finished the cheetah was really starting to look impressive.

STEP 5

All that was left to do was to add a little texture to the fluffy fur on the belly and also put in some shading. I used a 0.1mm pigment liner to add very fine hatched lines to evoke the fur, then turned to the 0.3mm pigment liner to stipple areas of dotted shadow on the neck and far legs of the cheetah. Using this stippling technique allows the pattern to remain visible even in shadowed areas. One of the best ways to suggest movement is to place the subject in a context, so that you have something to anchor, or in this case propel, your form in the composition. I simply added an area of stippled shadow and some rough spiky lines beneath the cheetah to suggest the grassy ground upon which he runs.

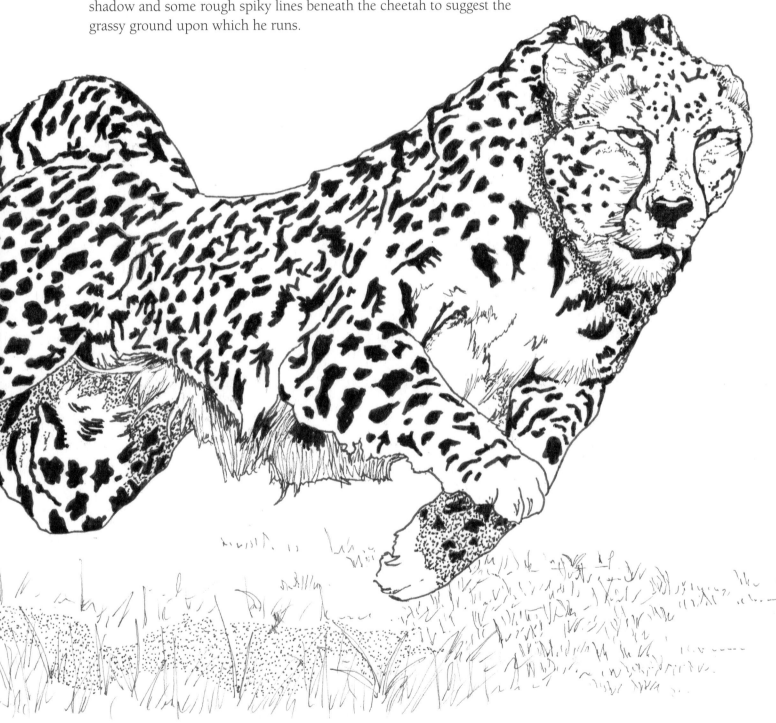

Whippet

You will need

300gsm (140lb) cartridge paper

HB propelling pencil

2B watersoluble pencil

8B watersoluble pencil

round watercolour brush (size 4)

A smaller and slighter version of the greyhound, the whippet is one of the fastest domestic dog breeds. In this drawing I wanted to show how in the gallop the legs gather together beneath the animal prior to the long-reaching stretch of the limbs depicted in the cheetah drawing (see page 72). I wanted to make the viewer really believe in the whippet's forward motion, so I added the splash of water beneath its feet to represent a moment of intense action and movement. I chose watersoluble pencil as my medium because it is good for creating soft, gradated tone – ideal for depicting liquid.

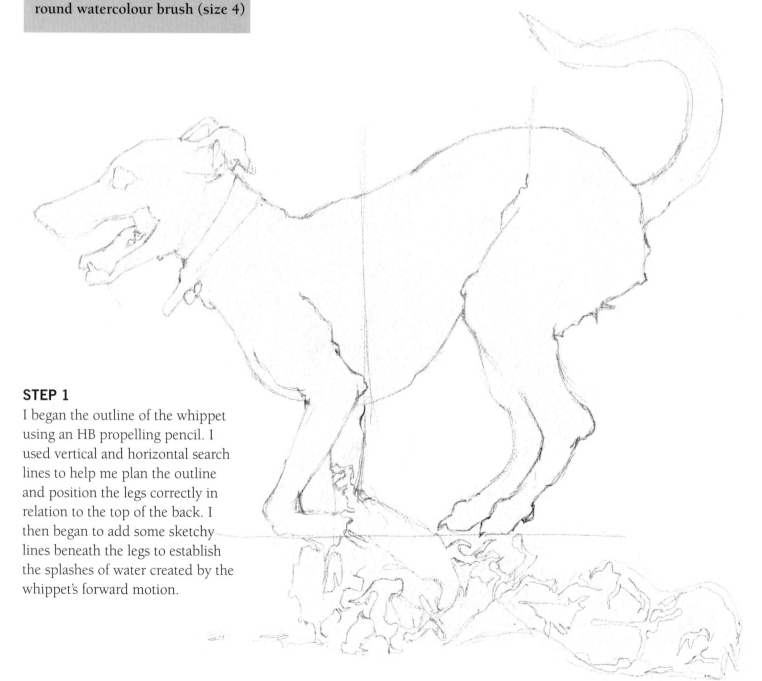

STEP 1
I began the outline of the whippet using an HB propelling pencil. I used vertical and horizontal search lines to help me plan the outline and position the legs correctly in relation to the top of the back. I then began to add some sketchy lines beneath the legs to establish the splashes of water created by the whippet's forward motion.

STEP 2

Using a 2B watersoluble pencil, I softly shaded the darkest tonal areas using circular scumbling motions. The collar, eye, and nose are solid black and I used the 8B pencil to establish this darkest tone.

Using a wet watercolour paintbrush I began to blend and soften the shading on the whippet's body. I then started to add shading to the splash with the 2B pencil.

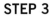

STEP 3

After blending the shading of the splash with my wet paintbrush, I started to add a darker tone to the light shading on the body, using the 8B pencil. I also picked out the darkest tones on the splash as well. Once I had established the dark, light and mid-tones, I then added a further tonal layer of light shading on the whippet's chest and haunches, which adds texture as well as tone.

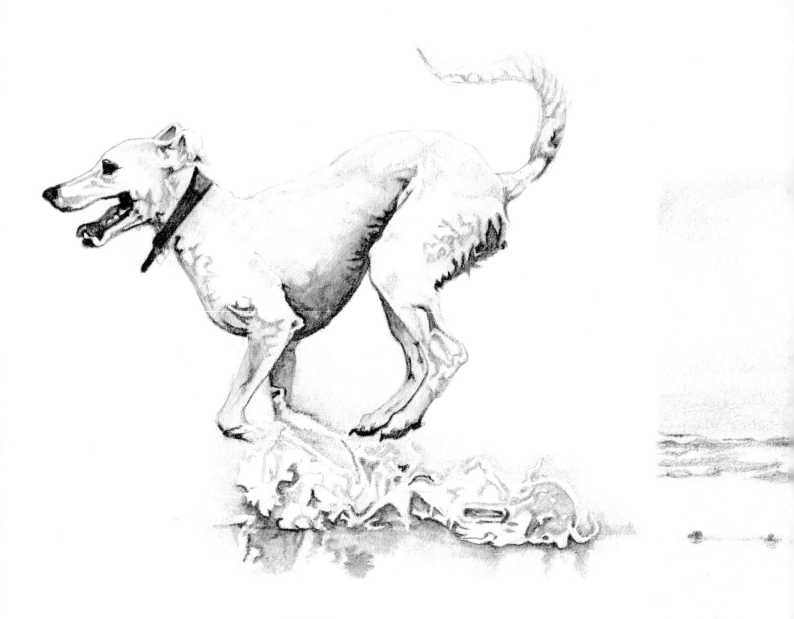

STEP 4

I added a wash covering the whole of the body to blend together all of the pencil shading, giving the form cohesion. I added some light shading around the edges of the splash to suggest the ground and also to throw the light parts of the water into focus.

STEP 5

I used this final step to unify the dog and splash with the background. I began by adding a horizon line to suggest where the land and sky meet; I then added subtle shading to the background around the whippet and the splash with my 2B watersoluble pencil. With a moistened, round-tipped paintbrush I blended the shading to a smooth even finish. Finally I used my 8B pencil to add some darker specks to describe a few random pebbles scattered on the sandy beach.

Bald Eagle

You will need

160gsm (98lb) fine-grain
 cartridge paper

HB propelling pencil

charcoal pencil

tortillon

There are few sights as majestic as a bird cruising in effortless flight. While at first glance the wings and body might look just like a mass of feathers, when you examine the form closely you will see that there is a geometrical pattern which dictates the position of each feather. This pattern makes it easy to draw the bird once you have established your structure.

The bald eagle is a skilled bird of prey, swooping low over water and snatching fish from the surface with its large talons. I wanted to demonstrate the beauty of the structure of a bird's wing in the drawing and how the wing pushes against the air currents to buoy the bird up. The dark smokiness of charcoal against the white of the paper is perfect for showing the stark tonal contrast between the bird's white head and dark body.

STEP 1

I started by drawing the top of the eagle's head, beak and neck, then began adding lines to describe the top of the left wing. With these elements established, I used them as position references, drawing straight vertical and horizontal lines to place the rest of the bird's body parts correctly. When I came to the tip of the left wing, I made the feathers curve backwards slightly to suggest the force of the air pushing against them.

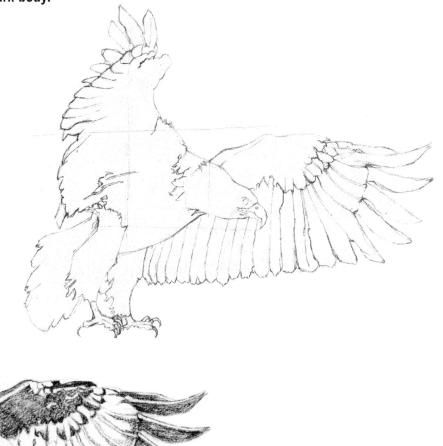

STEP 2

With my charcoal pencil, I roughly shaded in the darkest tones on the bird.

STEP 3

I used my tortillon to blend and smooth the charcoal shading, then, with the excess charcoal deposited on the end of the tortillon, I began to add a smoky mid-tone to the feathers of the wings and a light shadow under the neck.

STEP 4

In this final stage I darkened the body of the eagle even further and put in darker accents on some of the wing feathers. I added a regular feather pattern to the nearest leg, making sure the tip of my charcoal pencil was sharp. I then added a few dark lines to the neck to suggest feather texture in the mass of white. Finally I darkened the talons, making them stand out as sharp tools to catch prey.

Mallard Duck

Ducks are naturally at home in the air and on the water, with their waterproof feathers and webbed feet, so I decided to depict my duck in transition from one element to the other. The pose is perfectly balanced by the outstretched neck and extended wings, together with the reflection of the duck in the water upon which it is about to land.

You will need

300gsm (140lb) watercolour
 paper
HB propelling pencil
black watercolour pan
round watercolour paintbrush
 (size 4)

STEP 1

I lightly sketched the outline of the mallard with the HB propelling pencil and established the structure of the wing feathers with straight lines radiating from the edge of the wing.

STEP 2

I mixed a very light wash using a small dab of paint from the black watercolour pan and marked out the darkest areas of the mallard. I then added a wash to the area of reflection in the water. It is always best, with watercolour, to start your work with light tones; it is very difficult to remove paint once it has been applied and a paint-heavy picture can look dull and overworked. It is important to maintain the fresh immediacy that is so beautiful in watercolour.

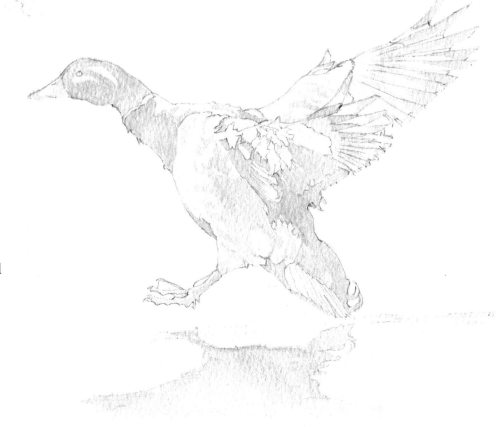

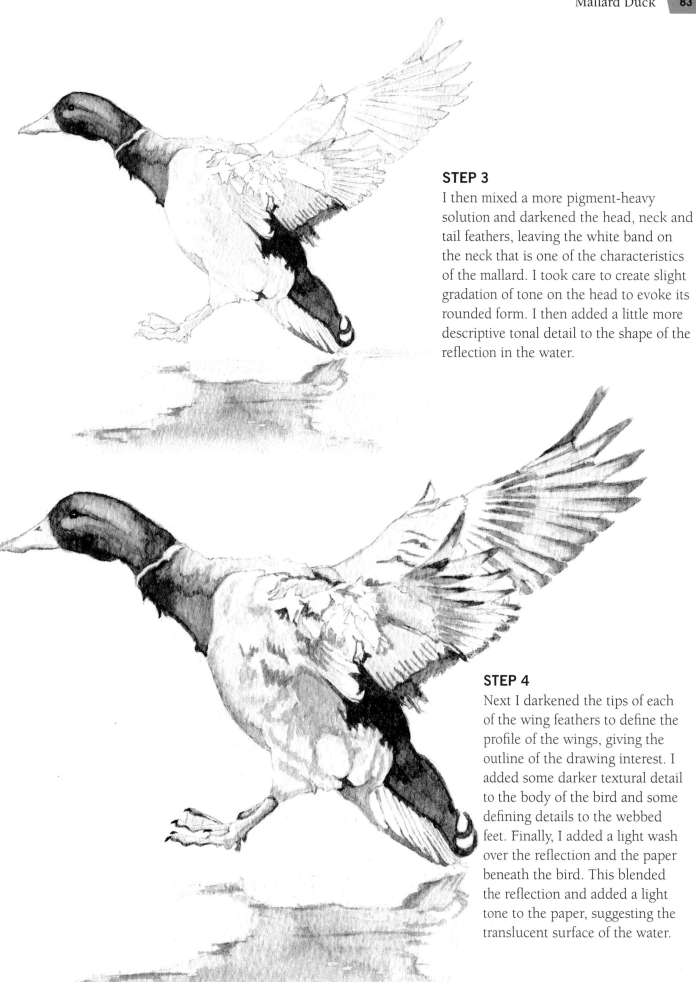

STEP 3

I then mixed a more pigment-heavy solution and darkened the head, neck and tail feathers, leaving the white band on the neck that is one of the characteristics of the mallard. I took care to create slight gradation of tone on the head to evoke its rounded form. I then added a little more descriptive tonal detail to the shape of the reflection in the water.

STEP 4

Next I darkened the tips of each of the wing feathers to define the profile of the wings, giving the outline of the drawing interest. I added some darker textural detail to the body of the bird and some defining details to the webbed feet. Finally, I added a light wash over the reflection and the paper beneath the bird. This blended the reflection and added a light tone to the paper, suggesting the translucent surface of the water.

Sea Turtle

Turtles have evolved the ability to swim underwater for long periods of time, absorbing oxygen through their gills. They have strong front legs shaped like flippers which paddle the turtle forward in the water. To evoke the invisible water surrounding the turtle in my drawing, I have shown the nearest flipper curving upwards as it pushes against the water beneath it.

You will need

300gsm (140lb) smooth cartridge paper (though you can use a lighter paper)

HB propelling pencil

0.3mm black pigment liner

0.5mm black felt pen

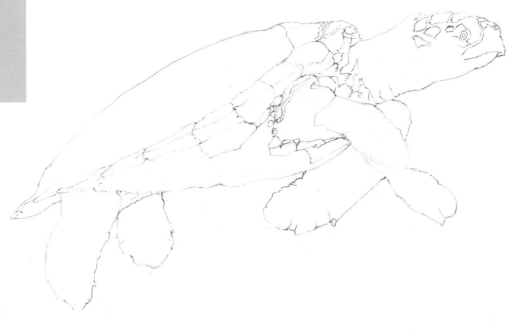

STEP 1

I drew the outline of my turtle with the HB propelling pencil. The turtle's shell is made up of interlocking plates and I began to suggest the structure of their pattern by sketching in the plates which run along the side of the body.

STEP 2

Using the 0.3mm black pigment liner, I inked over the outline of the turtle and the segments of shell. I then worked more upon the detail of the flippers and head, using the HB propelling pencil. The skin of the turtle has an interlocking plate pattern similar to the shell and I took time to mark out this pattern on the limbs and head.

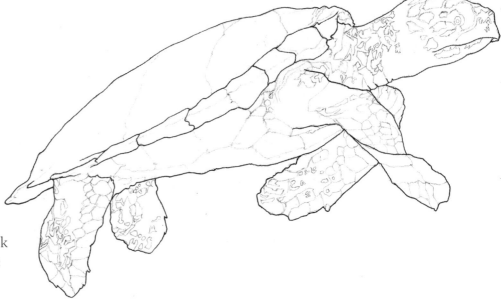

STEP 3

I used the 0.5mm felt pen to block in the solid black areas on the head and flippers. The preparatory pencil working made this stage easy and I could ink the black detail with confidence.

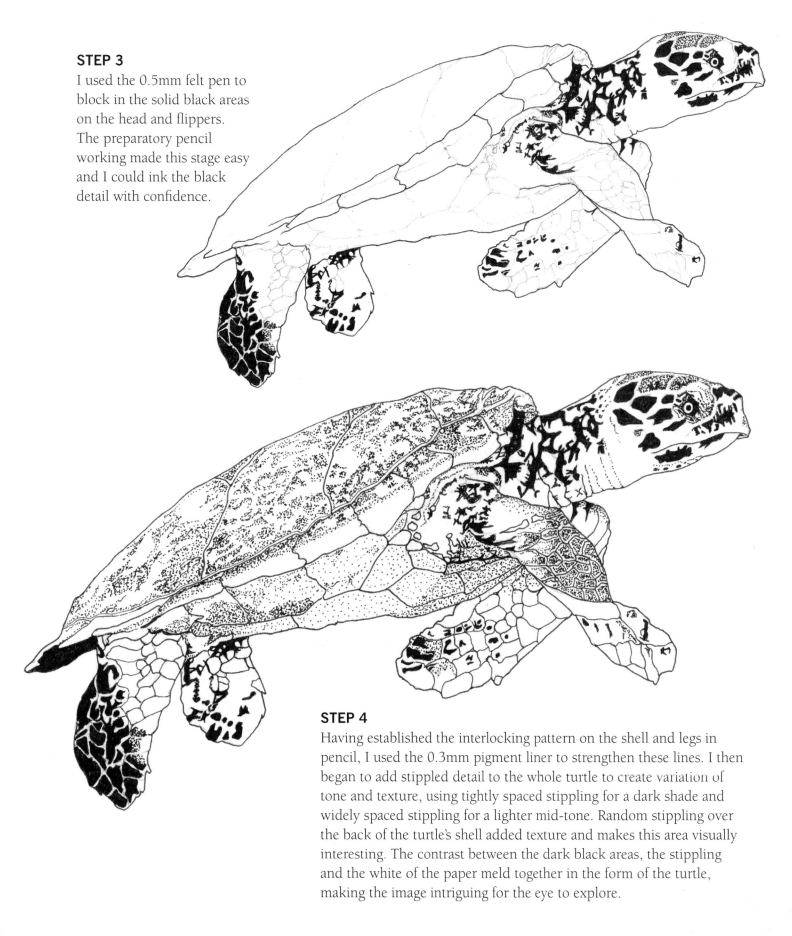

STEP 4

Having established the interlocking pattern on the shell and legs in pencil, I used the 0.3mm pigment liner to strengthen these lines. I then began to add stippled detail to the whole turtle to create variation of tone and texture, using tightly spaced stippling for a dark shade and widely spaced stippling for a lighter mid-tone. Random stippling over the back of the turtle's shell added texture and makes this area visually interesting. The contrast between the dark black areas, the stippling and the white of the paper meld together in the form of the turtle, making the image intriguing for the eye to explore.

Kangaroo

The key feature of any animal that hops, such as rabbits, kangaroos and frogs, is well-defined, strong back legs. It is from these that the main momentum comes to propel the animal forward – the front legs may be used as a brief prop while the back legs are off the ground, but in the case of kangaroos they are altogether superfluous to movement. It is the power of these hind legs that I wanted to capture in my drawing, along with the speed that kangaroos can achieve with their hopping gait.

You will need

160gsm (98lb) fine-grain
 cartridge paper
HB propelling pencil
black and grey soft pastels
tortillon

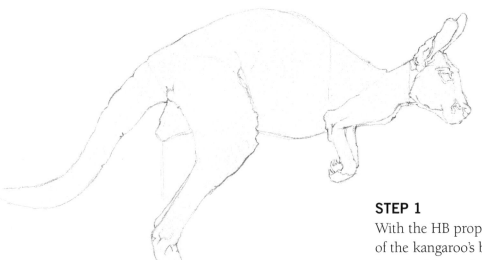

STEP 1

With the HB propelling pencil, I sketched in the line of the kangaroo's back. Using this line as reference, I marked in vertical lines to help me to locate the position of the 'elbows' and feet of the kangaroo. With the key elements established, I was then able to sketch in the remainder of the outline.

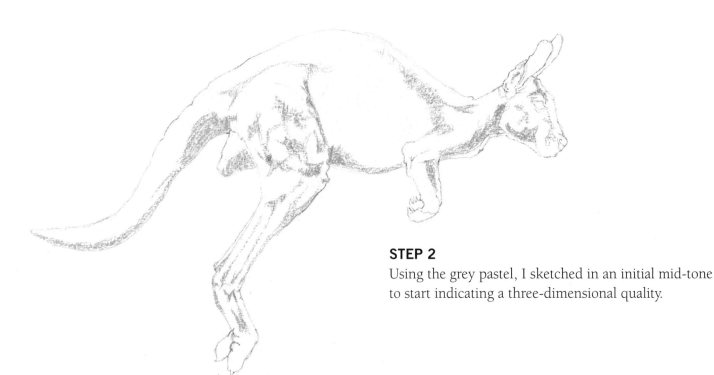

STEP 2

Using the grey pastel, I sketched in an initial mid-tone to start indicating a three-dimensional quality.

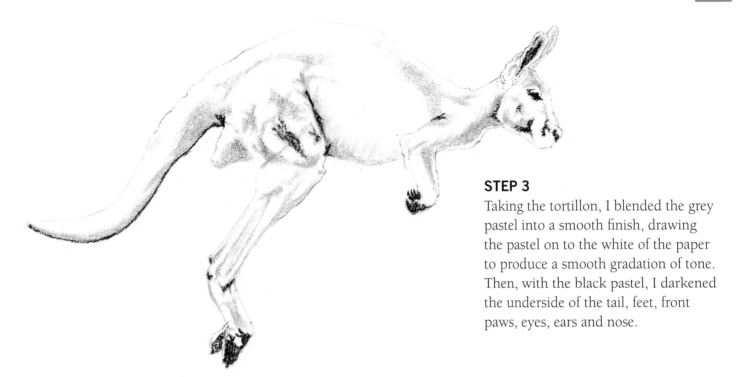

STEP 3

Taking the tortillon, I blended the grey pastel into a smooth finish, drawing the pastel on to the white of the paper to produce a smooth gradation of tone. Then, with the black pastel, I darkened the underside of the tail, feet, front paws, eyes, ears and nose.

STEP 4

I blended the black into the grey using the tortillon and began to add more textural fur detail to the body and haunches with the grey pastel. I wanted the back legs to appear really strong and muscular so I accentuated the modelling, adding darker patches and blending to add cohesion. I then added dark lines to the lower part of the leg to emphasize the taut tendons. Finally, holding the grey pastel on its side, I applied it lightly to the paper, then used the tortillon to rub smooth horizontal lines into the paper. This smudgy setting evokes the blurry background effect as the kangaroo speeds through the outback.

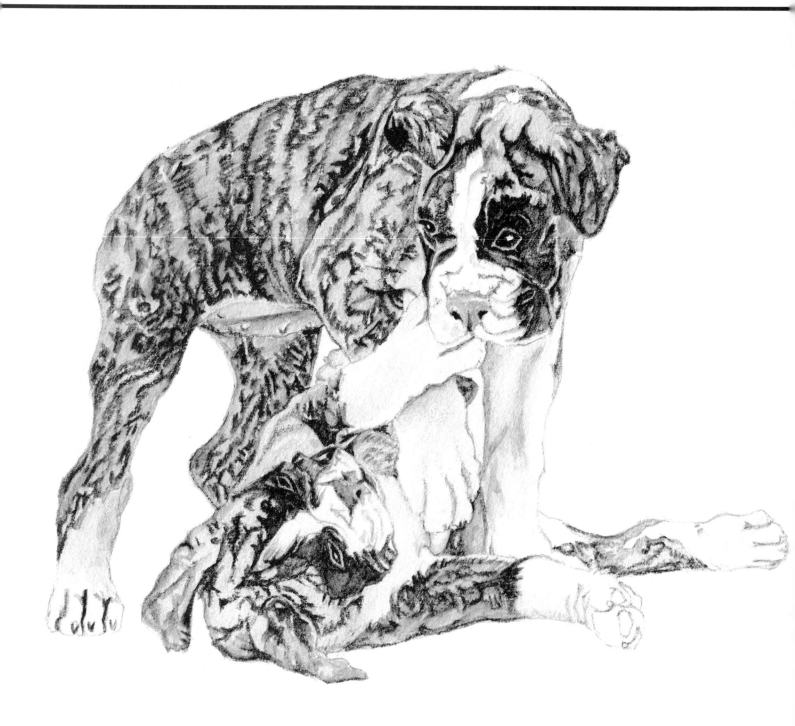

Chapter 5

ANIMAL INTERACTION

The variety of relationships within the animal kingdom is huge. Just like humans, the members of animal species interact for the purposes of survival, be it the protection of a parent for its offspring, the teamwork of a group of individuals searching for food or the competition between two dominant males in search of a mate to perpetuate the species.

The key to portraying an emotional interaction between animals is identifying how it is expressed in their physical attitude. Start by examining photographs of animals in their natural environment. Once you have identified a recognizable facial expression or body language that conveys an important emotion, you can begin to practise translating this into your drawings.

Body Language

You can tell a lot about animal interaction by examining the body language between a pair of individuals or within a group. As humans we are generally very good at identifying the meaning of an animal's body language; it is easy to detect aggression, love and fear by looking at how an animal carries itself physically. Once you have established what it is about the attitude of a pair of animals that expresses a particular emotional connection, you can begin to create images with real depth of feeling.

In Chapter 3 we looked at how an animal's facial expression conveys its state of mind (page 58). You can use this in combination with the body language of the animal you are depicting in order to really convey the connection between the animals you are drawing.

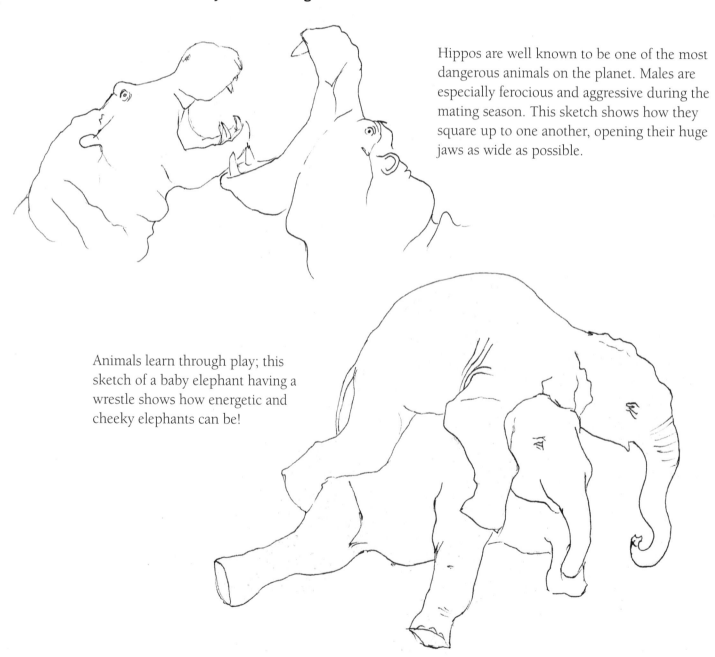

Hippos are well known to be one of the most dangerous animals on the planet. Males are especially ferocious and aggressive during the mating season. This sketch shows how they square up to one another, opening their huge jaws as wide as possible.

Animals learn through play; this sketch of a baby elephant having a wrestle shows how energetic and cheeky elephants can be!

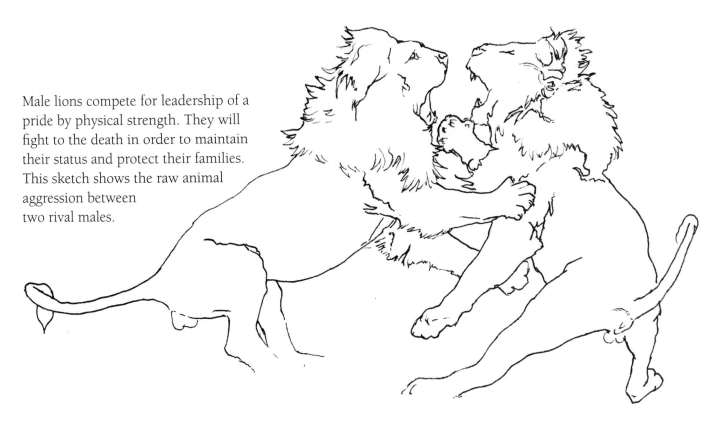

Male lions compete for leadership of a pride by physical strength. They will fight to the death in order to maintain their status and protect their families. This sketch shows the raw animal aggression between two rival males.

MATERNAL RELATIONSHIPS AND FAMILY BONDS

The survival of young in the natural world is almost totally dependent on nurturing from the parent animals. Like human babies, most newborn animals are defenceless and weak. They will be raised on their mother's milk, in the case of mammals, and later taught how to forage or hunt for their own food. These familial relationships are therefore very close; there is no stronger bond between animals than that of a mother and her young. Capturing this closeness in your drawings requires sensitivity in your depiction of the body language and interaction between them.

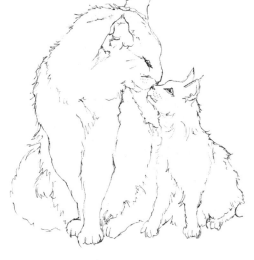

The family group is very important to a primate's survival. Grooming one another and maintaining close physical contact is a big part of ensuring the family ties remain strong.

Female cats are fiercely protective over their kittens. A mother will wash, feed and nurture her offspring until they are old enough to fend for themselves. Establishing eye contact and physical connections in your sketches is key to the successful depiction of motherly love.

Mother and Baby Elephant

A baby elephant is totally dependent upon its mother and exists entirely upon her milk until it is about two years old. Family is very important to the elephant and the bond between a mother and her calf is probably closer than in any other species; a female calf will often remain with her mother until the latter dies. I wanted to capture this intense, lifelong relationship in my drawing. Before I planned my composition I thought carefully about the body language that would express a loving, nurturing connection.

You will need

160gsm (98lb) cartridge paper

HB propelling pencil

black brush pen

0.3mm pigment liner

0.1mm pigment liner

STEP 1

I decided that a physically close depiction of the mother and baby elephant would be the best way to convey their special relationship. The trunk is to an elephant as hands are to humans, so I used this as the key demonstrative connection between the mother and her baby. I emphasized the importance of this link by placing the intertwined trunks in a relatively central focal point of the composition. We can relate to this demonstration of love and care and the viewer can therefore easily recognize what you are trying to convey in your drawing. I sketched my outlines of the two forms with an HB propelling pencil.

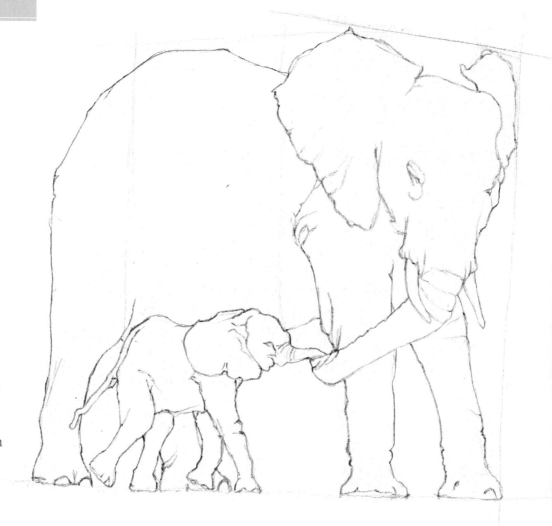

STEP 2

I wanted to establish the darkest tones early on in the process. This allows you to see the bold contrast between the white of the paper and the black of the ink – you can then work up detail to act as a connecting mid-tone between these tonal extremes. I used my black brush pen to block in the areas of shadow.

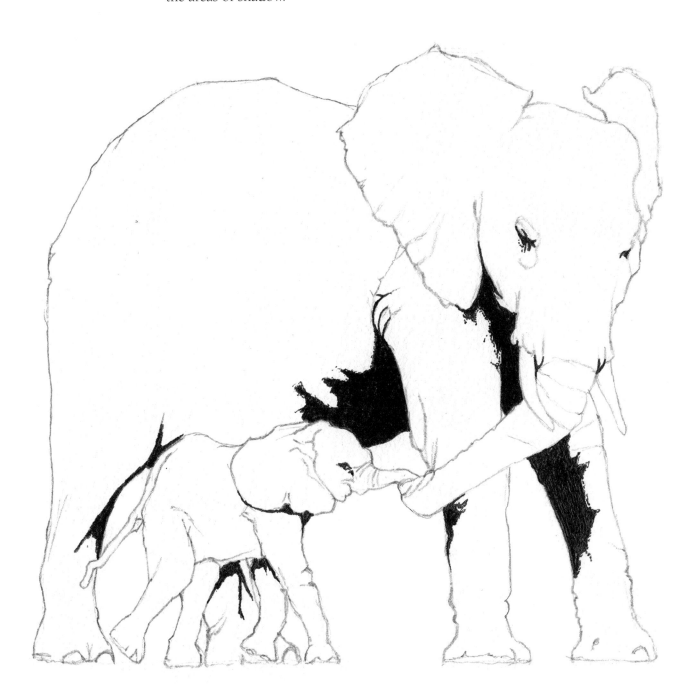

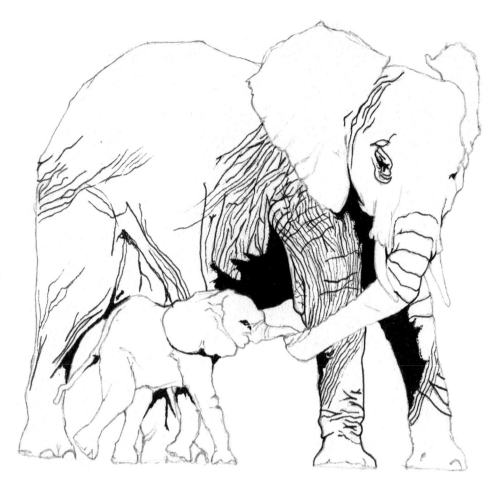

STEP 3

The beauty and interest of an elephant's skin comes from its amazingly intricate network of lines and wrinkles. I wanted to re-create this map-like covering in my drawing. Using a 0.3mm pigment liner I began to draw in the wrinkles, making sure the flow of my lines followed the three-dimensional form of the elephant's body.

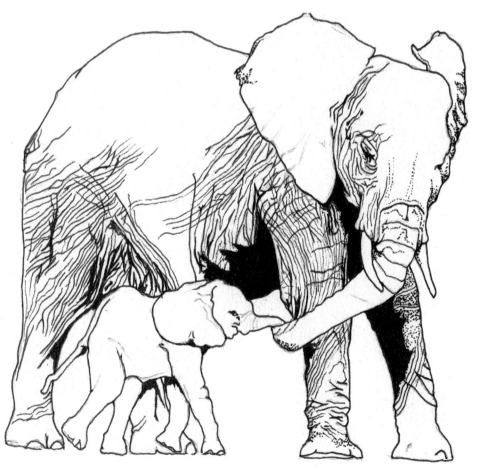

STEP 4

Next I inked over my preliminary pencil outline of the forms and continued adding to my line network.

STEP 5

I worked up the surface of the mother elephant into a crisscrossed network of lines. Using a 0.1mm pigment liner, I completed the uppermost area of her back by adding fine broken lines. I then finished work on the mother by stippling shadow into the ears and forehead and adding further stippling to blend the black areas more smoothly into the line network. This technique not only produces tonal variation, it also evokes the texture and solidity of the form. I wanted to emphasize the difference in surface texture between the mother and the calf so I kept the detail sparse on the latter, using the 0.1mm pigment liner to add a few fine lines and stipples. Finally I added a few random sketchy lines and dots around the feet of the elephants to suggest grass. This really anchors the pair and unites them firmly within the composition.

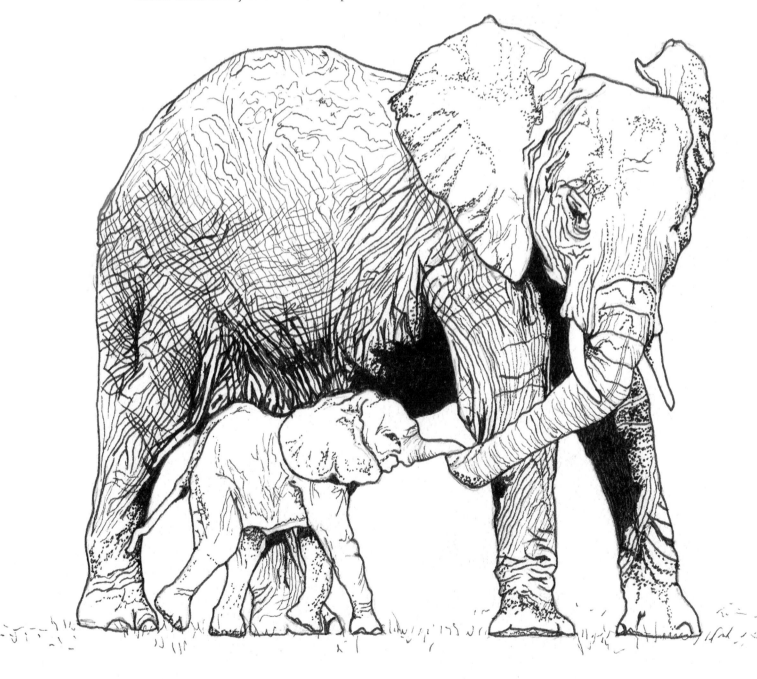

Monkey Family

The rhesus macaque is one of the most widely distributed species of monkey. As they often live in huge groups of up to 200 individuals, social interaction is extremely important to these monkeys and they use a large variety of facial and physical expressions in order to communicate. They are highly intelligent and sensitive and this is clearly evident when you look at photographs of families – they are attentive to their young and show respect for social hierarchy within the group. In this composition I wanted to convey the close relationships that monkeys have with each other and also their sensitivity and interaction with the outside world.

You will need

300gsm (140lb) watercolour
 paper

HB propelling pencil

black watercolour pan

round watercolour brush
 (size 4)

flat watercolour brush (3/16")

STEP 1

Again I wanted to show the closeness between a mother and her young, but with another dimension to my drawing. The mother nurses her baby, an act which she must concentrate upon totally. Her gaze and body language are entirely focused upon her offspring, so she cannot watch out for danger. I added another monkey who sits as sentinel, looking out from the picture with a direct stare that engages the viewer. The composition shows how important the extended family group is to the survival of these animals. I sketched in this preliminary outline with an HB propelling pencil.

STEP 2

Wetting the black watercolour pan, I mixed a dilute paint solution and used the round brush to apply a light mid-tone. I applied the paint with loose brush strokes which begin to establish the texture of the monkeys' fur.

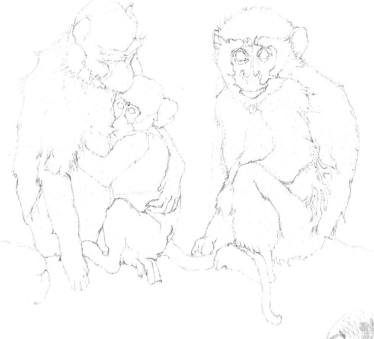

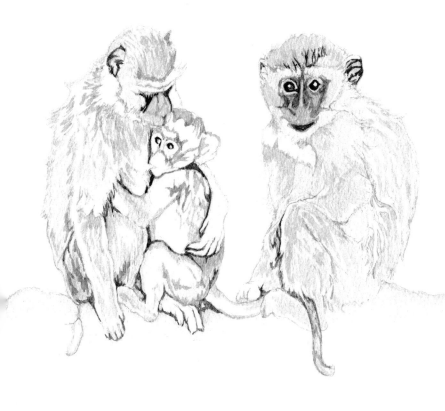

STEP 3

With a more pigment-heavy solution, I darkened the eyes, ears, faces and the outline of the baby monkey. I then added more textural detail to the bodies.

STEP 4

I allowed my work to dry thoroughly and then added a light wash over all three monkeys. While this wash was still damp I began to brush in some darker strokes, adding to the fur texture of the monkeys. The moist paper allowed the paint to bleed slightly, creating a lovely diffuse finish. I kept the baby monkey slightly smoother than the adults to emphasize its youth and vulnerability. Finally I used a flat brush to wet the paper beneath the monkeys, then, loading the brush with pigment, I smoothed it over the damp paper. This wet-on-wet technique creates beautifully subtle effects.

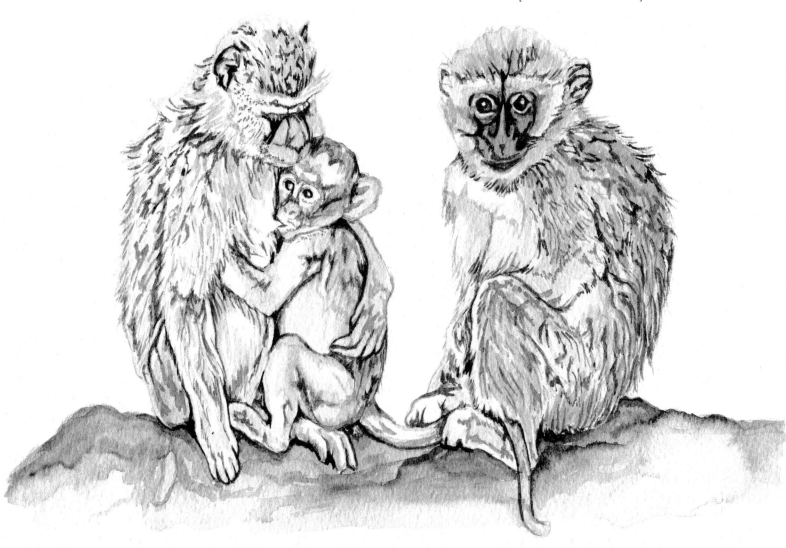

Lioness and Cub

Lions are the most sociable species of big cats and they live in 'prides', which are matriarchal groups consisting of around six females and their cubs and one or two males. When the lioness first gives birth to her cubs she separates herself from the pride for a couple of months and finds secure dens where she can nurse her offspring. If she stayed with the pride she would run the risk of other adult lions harming her cubs. I set out to convey this single-minded, solitary devotion of the mother lion in my drawing.

You will need

160gsm (98lb) fine-grain
 cartridge paper
HB propelling pencil
white, grey and black soft
 pastels

STEP 1

As with my depiction of the mother and baby elephant (page 92), I felt that the best way to evoke the relationship between the lioness and her cub was to establish a physical closeness in my drawing. They lie shoulder to shoulder, with the cub's small paw resting upon its mother's. The cub stares straight out of the drawing, establishing a connection with the viewer. The mother's face is located centrally and her gaze is directed to the right, bringing the viewer's focus on to the cub. This harmonious composition implies a quiet moment but also evokes the constant state of alertness of the mother, who must always be on the lookout for predators that might harm her cub. Having devised the layout of my composition, I sketched in the outline using an HB propelling pencil.

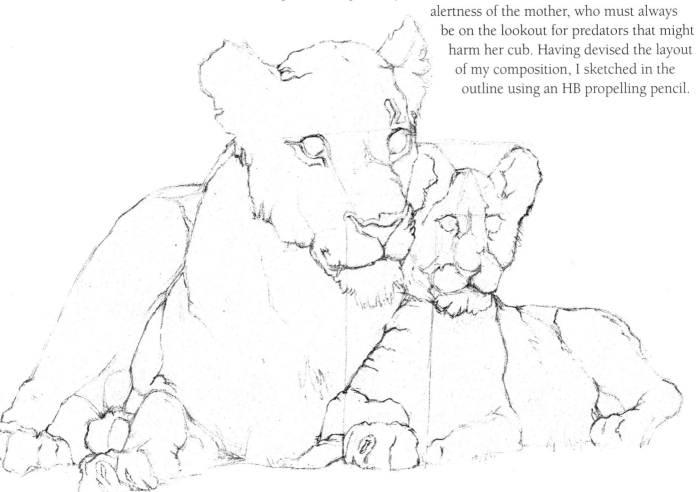

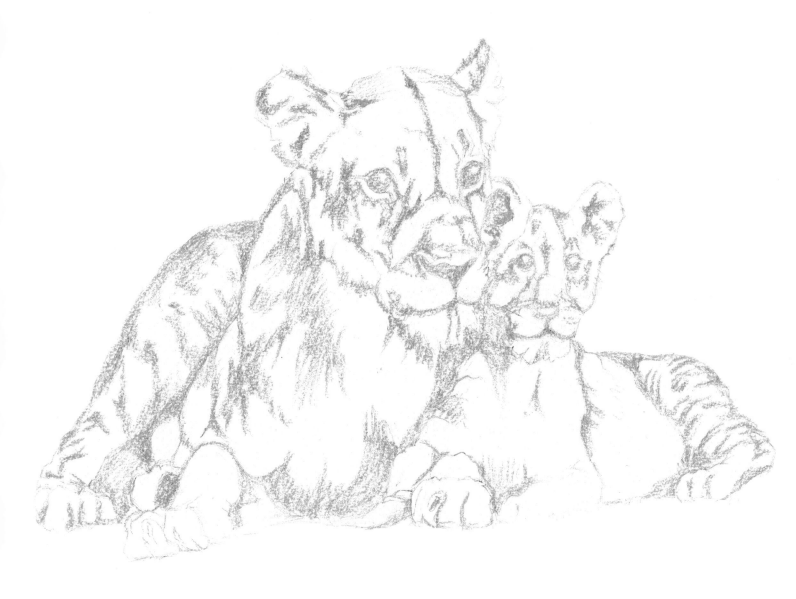

STEP 2
Using a grey soft pastel I shaded in a light mid-
tone, paying attention to the areas of shadow
upon the bodies of the lions.

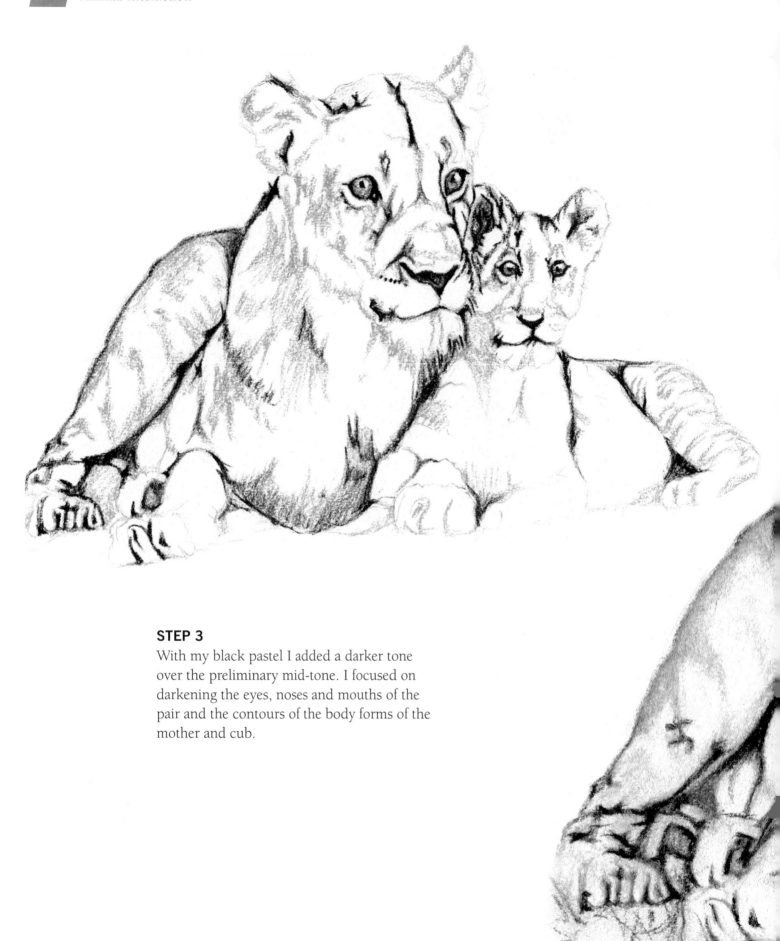

STEP 3

With my black pastel I added a darker tone over the preliminary mid-tone. I focused on darkening the eyes, noses and mouths of the pair and the contours of the body forms of the mother and cub.

STEP 4

I then used the white pastel to blend and unify the tonal range of the forms, rubbing the pastel quite hard into the surface of the paper. The white pastel produces luminous highlights and where it meets the darker tones the effect is one of smooth and subtle gradation. It is a soft-focus effect that lends itself perfectly to evoking the smooth fur of the lions' coats. Finally, I used the black pastel to add some short lines around the lions' feet to evoke the grassy plain upon which they sit.

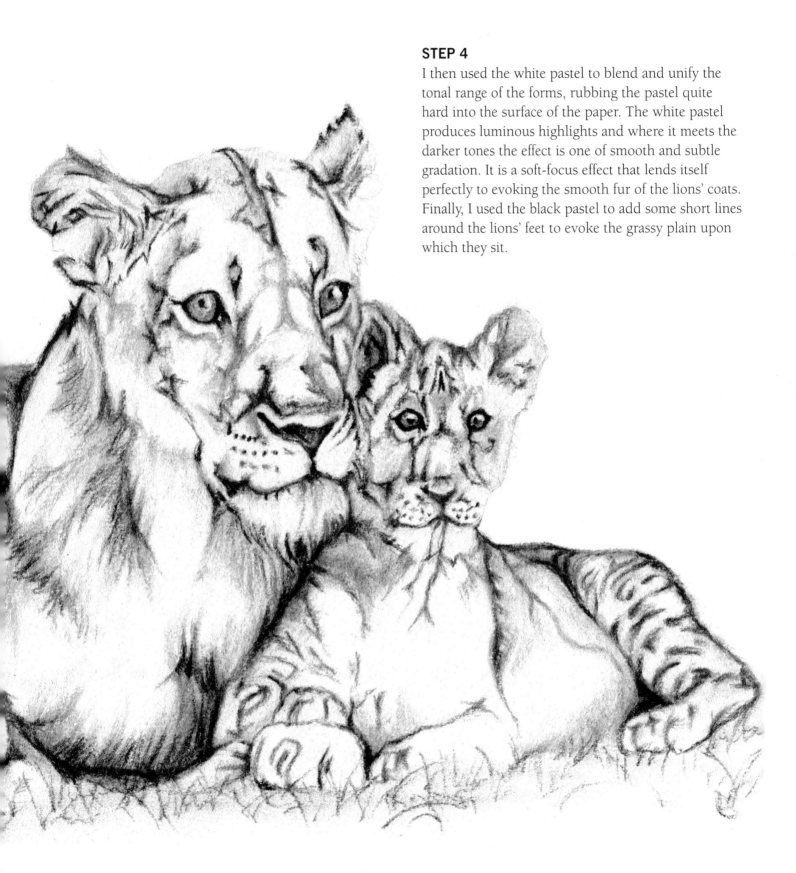

Boxer Puppies at Play

We have all seen clumsy play-fights between puppies and kittens and there is nothing cuter. However, play performs a very important role in the life of any young animal. It teaches them the dos and don'ts of survival – hunting tactics, building relationships within a family group and the ability to watch out for and recognize danger. Dogs, like humans, also play for the pure fun of it! It relieves stress and boredom and helps to keep an animal fit. I wanted to combine this idea of fun and learning in my depiction of pups at play.

<div>

You will need

300gsm (140lb) cartridge paper

HB propelling pencil

HB watersoluble pencil

8B watersoluble pencil

round watercolour brush (size 4)

</div>

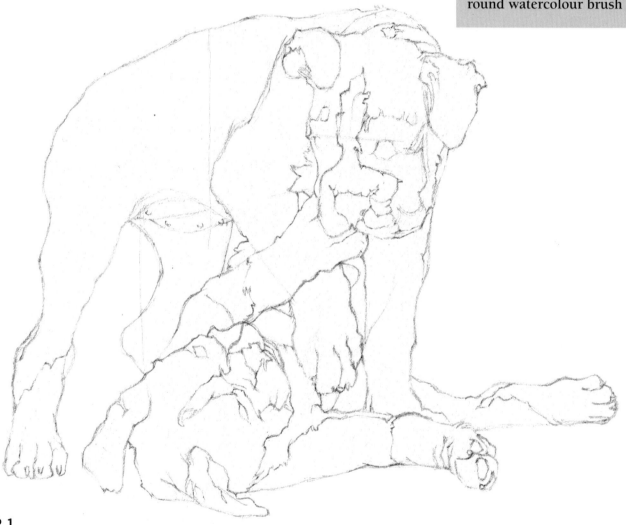

STEP 1

Physical play often takes the shape of dominant and submissive interaction – roles that will be exchanged frequently throughout the game. One dog will stand above the other while it rolls over showing its belly, a characteristically submissive pose. To convey that this is not a threatening interaction I imbued my submissive puppy with the same spirit and character as the dominant pup, showing him playfully kicking his legs. I drew my outline using an HB propelling pencil, making sure that the crossing of the puppies' front legs was placed centrally in my composition to mark out the hub of the action.

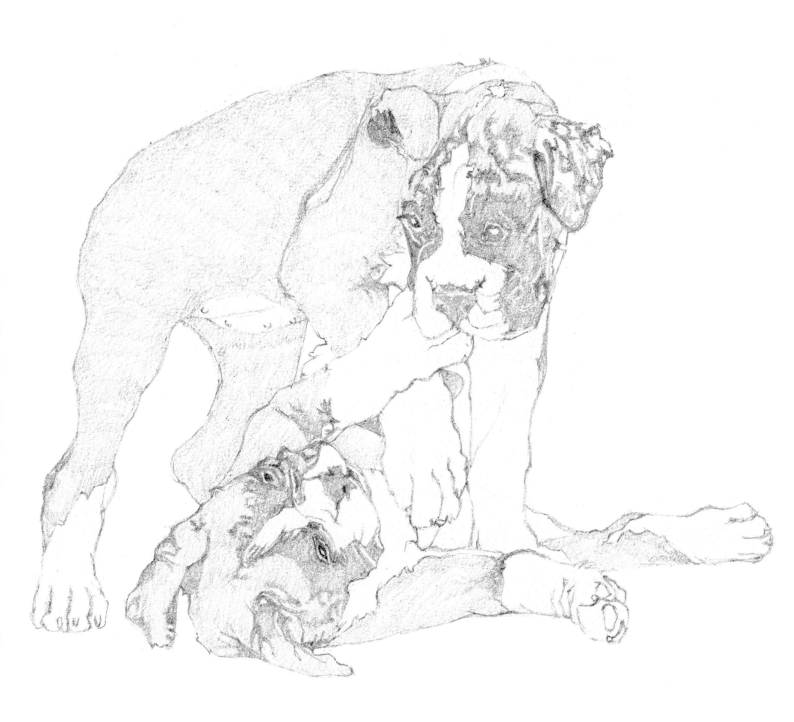

STEP 2

I used the HB watersoluble pencil to shade the bodies of the pups evenly, leaving out their white socks. Taking the 8B watersoluble pencil, I shaded in the forehead wrinkles and black mask-like markings on their faces.

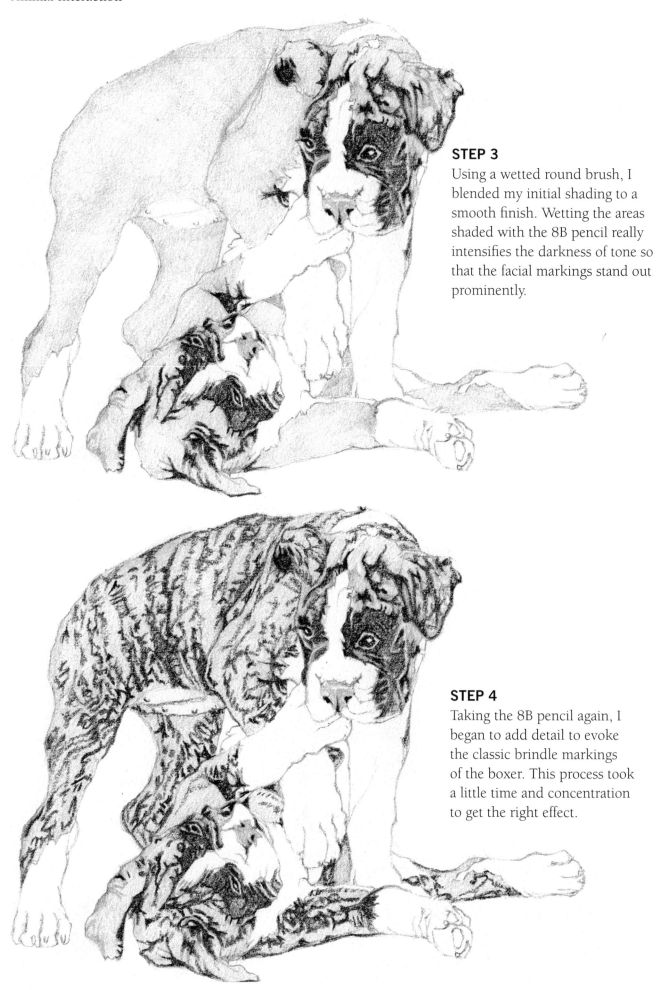

STEP 3
Using a wetted round brush, I blended my initial shading to a smooth finish. Wetting the areas shaded with the 8B pencil really intensifies the darkness of tone so that the facial markings stand out prominently.

STEP 4
Taking the 8B pencil again, I began to add detail to evoke the classic brindle markings of the boxer. This process took a little time and concentration to get the right effect.

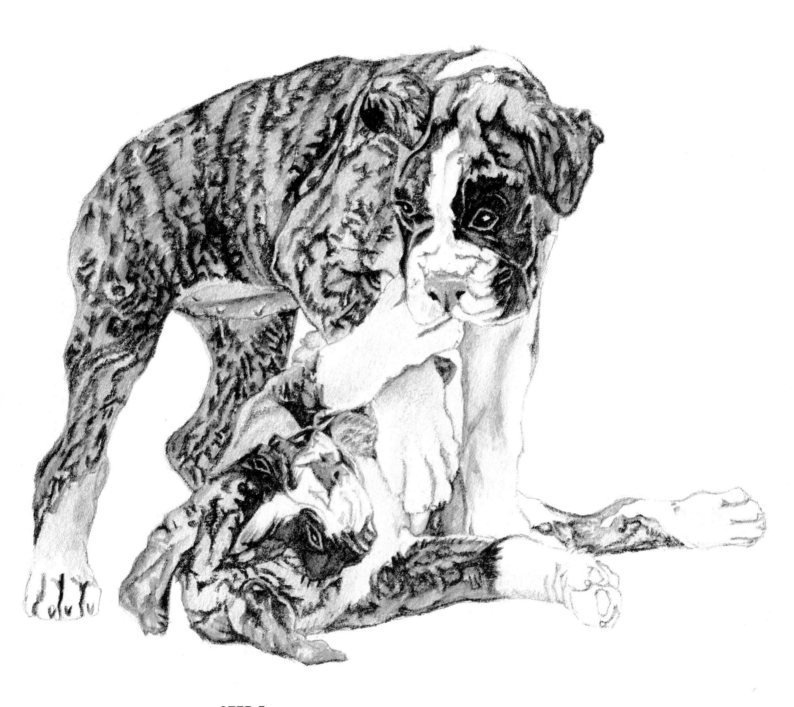

STEP 5

Using a wet brush, I began to blend the brindle markings into the
rest of the fur, so that they became smoother and more subtle while
at the same time retaining their pattern. Using the excess tone on
my brush, I began to add subtle shading to the untouched white
markings. This final process unites the tonal variation within the
composition and gives the image a sense of depth and substance.

Great Crested Grebes Courting

All animals are programmed to find a mate in order to reproduce. Competition for a partner is tough and many animals have developed elaborate courtship rituals. Male birds often have beautiful feathers which are used to create amazing displays to tempt the female bird into mating, the peacock being a prime example. Great crested grebes, identifiable by their long pointed beaks, the ruff of feathers around their necks and the crested plumage on their heads, have a long and elaborate courtship routine which involves the male and female bird mirroring one another's movements. This behaviour helps the pair to establish the close relationship which is required of parent birds so that they have the best chance of raising their chicks safely into adulthood.

You will need

160gsm (98lb) fine-grain

 cartridge paper

HB propelling pencil

charcoal pencil

tortillon

STEP 1

The key feature of the grebes' courtship is their imitation of each other. I wanted to catch the symmetrical beauty of this but at the same time convey the idea of their interaction as a fluid dance, so I did not make them entirely symmetrical; instead, I drew them as if they are just circling out of mirroring one another face to face, ready to move on to the next stage of their courtship. I sketched in their outlines using an HB propelling pencil.

STEP 2

The darkest parts of the grebe's plumage are its crest and neck ruff. I used my charcoal pencil to block in the tone of these distinctive markings. I then darkened the beak detail and the eyes, making sure I left a white highlight to convey their glinting surface.

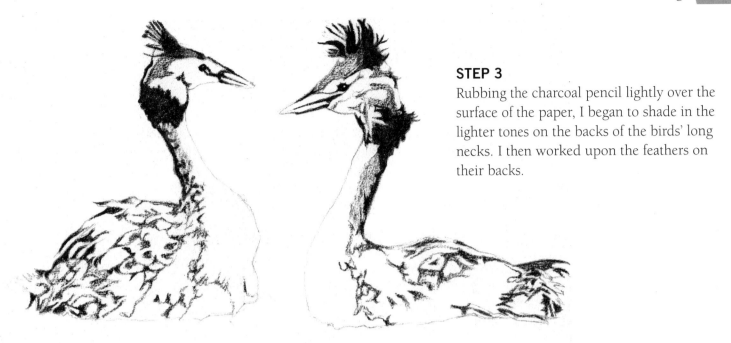

STEP 3

Rubbing the charcoal pencil lightly over the surface of the paper, I began to shade in the lighter tones on the backs of the birds' long necks. I then worked upon the feathers on their backs.

STEP 4

Using the tortillon, I blended all this marking to a unified, smooth finish. I then worked on evoking the water upon which the grebes float. I started by applying the charcoal pencil with a firm pressure to the lines where the bodies of the birds break the surface of the water. I then worked from these initial lines to create further dark ripples, allowing the white of the paper to show between. Finally, I blended in mid-tone shading using the tortillon and subtly smoothed my existing darker lines. The contrast between the dark and light creates a beautiful liquid effect, evoking the shining surface of the grebes' watery habitat.

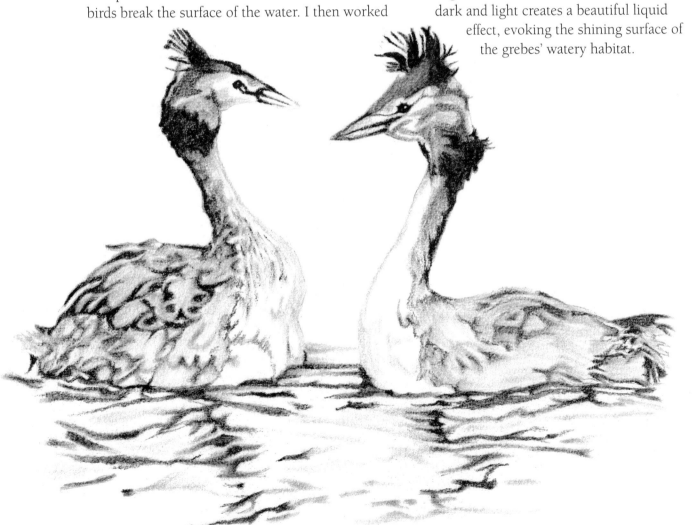

Chapter 6

ELEMENTS OF COMPOSITION

Composition means the design of your picture – how the various elements of your drawing are placed in relation to each other. Understanding what makes a successful composition will enable you to really take control over what you want to say with your work of art, guiding the viewer through your drawing so that their eye takes a journey in which it focuses on what is important in the picture. You will always need to make choices as to how you arrange the components of your drawings, and making the right ones will result in drawings that attract and hold the viewer's attention.

Rules of Composition

There's no magic formula to guarantee a great composition – it's mostly about instinct. However, there are a few general rules that will help you at the start of your exploration into composition.

SIMPLICITY

Don't over-complicate your pictures. Before you start drawing, think about what you want to achieve with your picture and the feeling you want to convey to the viewer. A clear depiction of your subject will allow it to speak for itself.

FOCUS ON THE SUBJECT MATTER

Whether your composition is made up of one primary subject or a number of interacting elements, make sure that you establish where and how you want your viewer to focus. Use visual links between the elements to guide the eye through the picture.

UNITY

One of the most important features of a successful composition is harmony – making sure all the features within your drawing look as though they belong together and not just as if they have been put randomly on the page. A good way of achieving unity within a composition is to plan your picture using quick thumbnail sketches. Thumbnails allow you to record visual ideas quickly and you can use them to develop a compositional idea, incorporating elements that work well and discarding those that do not.

VARIETY

If you're drawing a group of animals, don't make them all the same – vary their stance and expression. The eye is naturally more drawn to variety, since it is more interesting and provokes more thought than a picture made up of similar components.

THE RULE OF THIRDS

This is a great way of laying out your composition to establish an underlying structure that will give unity and balance to your picture while at the same time achieving an interesting tension.

Divide your page horizontally and vertically into thirds, then sketch in the key elements of your composition near to where the horizontal and vertical lines intersect. The eye will naturally be drawn to these points of intersection and consequently you can control what the viewer focuses upon in the composition.

This structured way of organizing your page gives unity to the separate components of your drawing while at the same time allowing your main subject matter to speak for itself, enhanced rather than dominated by the background elements.

TAKING THE DOG FOR A WALK

The rule of thirds is particularly effective for organizing a picture of figures within a landscape. It is an easy formula that you can rely on to help you create tension and unity between your primary focal points and the landscape. This scene was inspired by walks in my local park, where I felt the beautiful old house would make a perfect backdrop to set off my figures in a landscape. I decided to execute this drawing in watercolour as it is a fantastic medium with which to paint landscapes – it has a beautiful subtlety but can also be used to bring out areas of intense shade.

You will need

300gsm (140lb) watercolour

 paper

HB propelling pencil

black watercolour pan

round watercolour brush (size 4)

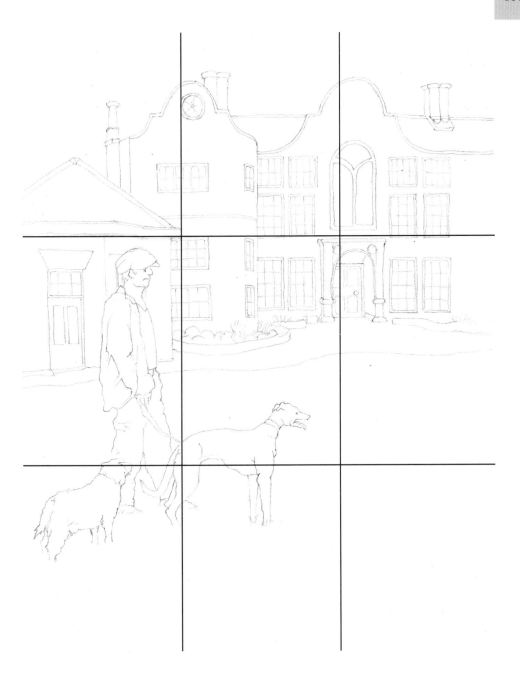

STEP 1

Before I started to sketch in the outline of my house and figures I began to plan my composition according to the rule of thirds. I wanted the action of the figure walking the dogs to be the primary focus of the picture, with the background the secondary point of interest. I placed the man just in line with the edge of the left-hand third of the page, with the dogs in line with the lower third. This creates an effective pyramid of action which extends into the centre of the composition. The eye of the viewer can then be led from this primary focus to admire the architectural beauty of the house. I sketched in my main outlines with an HB propelling pencil.

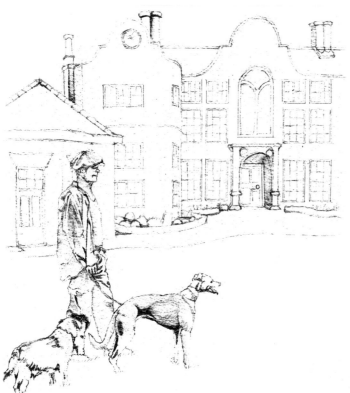

STEP 2

I mixed a very dilute solution of paint using the black watercolour pan and began to work on the modelling of the man and the dogs, loosely working in shadows on the man's shirt and the bodies of the dogs so that these forms started to gain a solidity. To counterbalance this working in the background, I began to add some light shading to the portico and chimneys of the house.

STEP 3

I wanted the windows to play a key decorative role in this composition and so, using a pigment-heavy paint solution, I began to shade in the panes of glass between the frames. Then, using a fairly dilute wash, I shaded the walls and roofs. This really throws the white of the windowframes into focus.

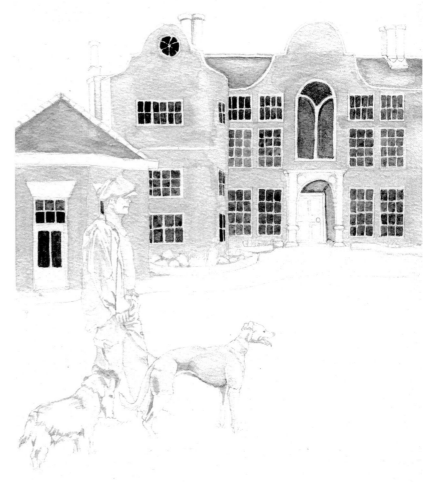

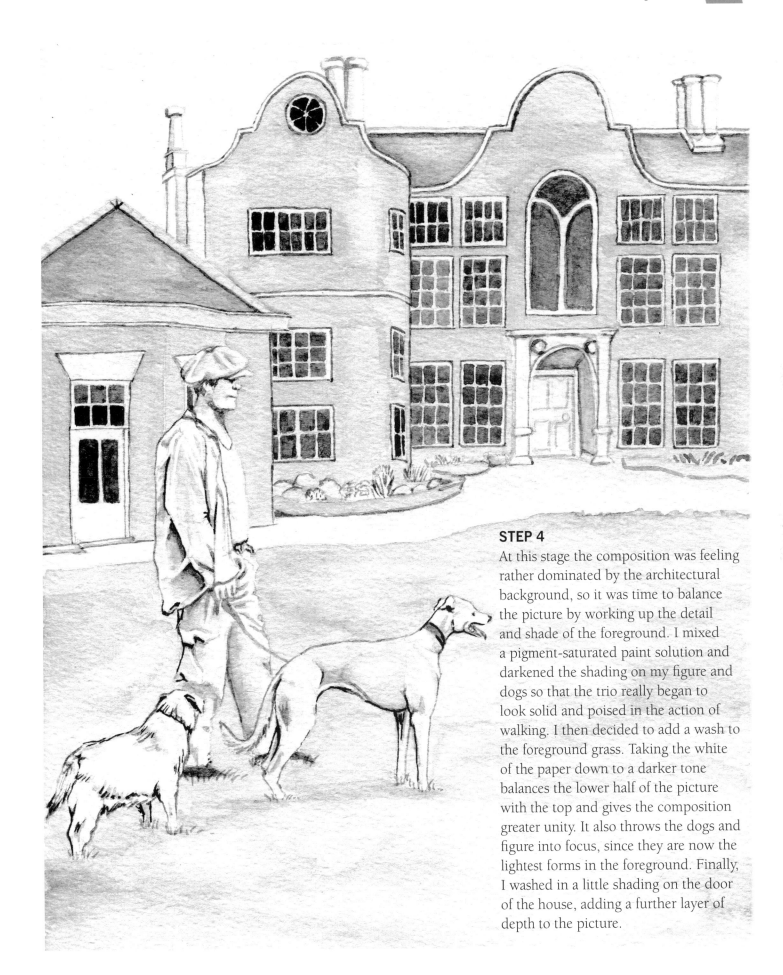

STEP 4

At this stage the composition was feeling rather dominated by the architectural background, so it was time to balance the picture by working up the detail and shade of the foreground. I mixed a pigment-saturated paint solution and darkened the shading on my figure and dogs so that the trio really began to look solid and poised in the action of walking. I then decided to add a wash to the foreground grass. Taking the white of the paper down to a darker tone balances the lower half of the picture with the top and gives the composition greater unity. It also throws the dogs and figure into focus, since they are now the lightest forms in the foreground. Finally, I washed in a little shading on the door of the house, adding a further layer of depth to the picture.

Perspective

Understanding how to implement the rules of perspective within your compositions will enable you to suggest a three-dimensional scene upon the two-dimensional surface of the paper. It is a way of drawing what the eye actually sees in the real world, so by incorporating perspective into your drawings you will be able to create pictures that appear convincing. Learning how to execute a perspective diagram correctly will enable you to create compositions with depth and help to establish a visually believable relationship between your animal subject and its environment.

SINGLE-POINT PERSPECTIVE

This is the simplest type of perspective, but it will enable you to achieve really impressive results. Single-point perspective has one 'vanishing point' on your horizon line to which all parallel vertical lines converge. Single-point perspective diagrams can be used to help you draw roads or paths vanishing into the distance (see below) as well as cubes or cuboids with the front facing the viewer (see above right). This way of drawing a cube can act as a framework to help you work out the perspective for more complicated forms such as your animal subjects.

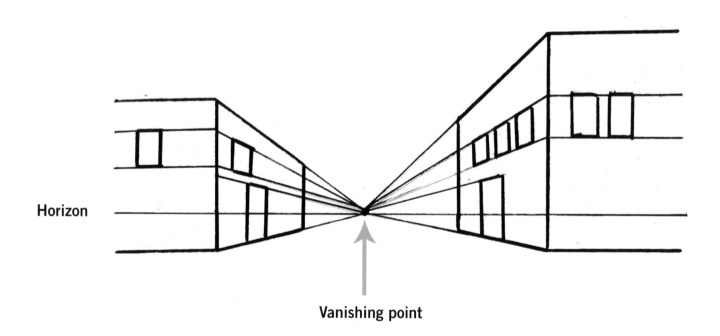

Horizon

Vanishing point

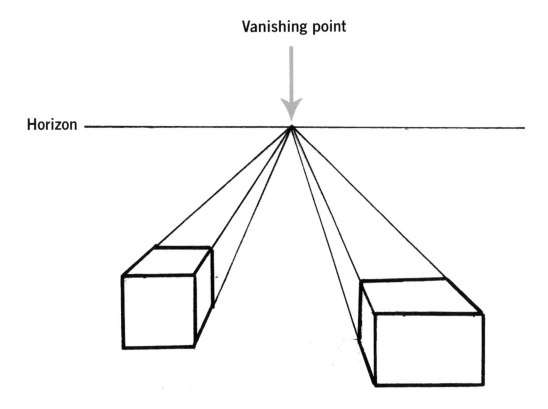

Vanishing point

Horizon

TWO-POINT PERSPECTIVE

As you might guess from the name, two-point perspective has two vanishing points located upon your horizon line; from these, lines can be drawn to the top and bottom of a vertical line which can be placed above, below, or across your horizon line. The diagrams show how you can easily create a cube at an angle to the viewer. Again this method of constructing a cube can be used as a guide to help you get the perspective right for more complicated forms.

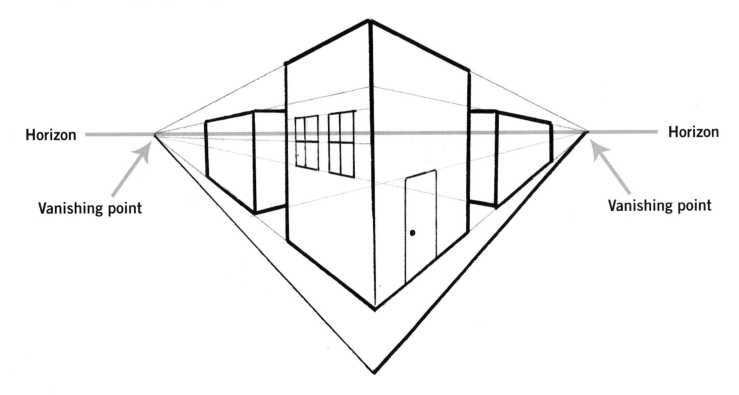

Horizon

Vanishing point

Horizon

Vanishing point

HORSES ON THE BEACH

Horses love the feel of sand beneath their hooves and the beach is one of their favourite places to gallop at full pelt. With this composition I wanted to use the rules of perspective to convey the idea of forms receding into the distance, emphasizing movement.

You will need

300gsm (140lb) cartridge paper

HB propelling pencil

0.3mm pigment liner

0.1mm pigment liner

black felt pen

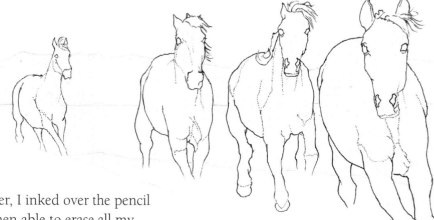

STEP 1

I began by roughly laying in perspective lines to mark out the top and bottom of the forms of my horses, using my HB propelling pencil. The vanishing point of the lines would in fact be off the page, but this doesn't really matter – you don't have to be too scientific about your use of perspective. I began to sketch in the horses, planning the position of each one quite carefully to ensure a smooth journey across the composition for the viewer. I grouped the first three horses quite closely together so they become a cohesive group. The horse that brings up the rear at the very edge of the composition helps to increase the sense of depth.

STEP 2

With my 0.3mm pigment liner, I inked over the pencil outline of my horses. I was then able to erase all my preparatory working.

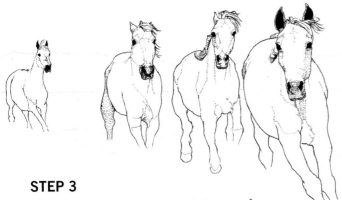

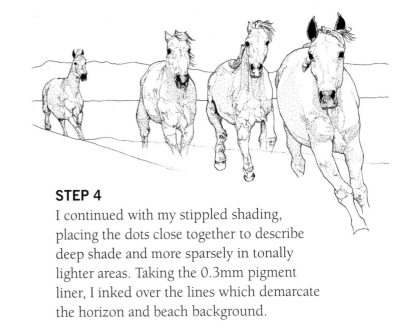

STEP 3

The next step was to start giving my horses three-dimensional substance. I inked in the darkest areas – the nostrils, eyes and ear cavities – with my black felt pen. I then began to add some stippled shading to the bodies with the 0.1mm pigment liner. This stippling adds texture to the image and the composition really starts to become interesting to look at.

STEP 4

I continued with my stippled shading, placing the dots close together to describe deep shade and more sparsely in tonally lighter areas. Taking the 0.3mm pigment liner, I inked over the lines which demarcate the horizon and beach background.

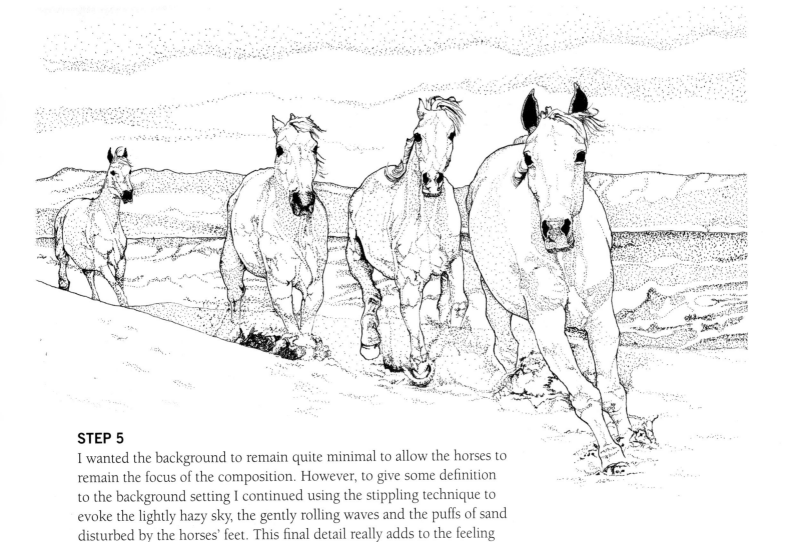

STEP 5

I wanted the background to remain quite minimal to allow the horses to remain the focus of the composition. However, to give some definition to the background setting I continued using the stippling technique to evoke the lightly hazy sky, the gently rolling waves and the puffs of sand disturbed by the horses' feet. This final detail really adds to the feeling of movement in the composition.

IN THE FARMYARD

This composition demonstrates how easy it is to use two-point perspective to create buildings that appear visually realistic and three-dimensional. A farm setting such as this is ideal for an exploration of playing with different visual planes – the far distance, middle distance and foreground.

You will need

300gsm (140lb) cartridge paper

HB propelling pencil

0.3mm pigment liner

0.1mm pigment liner

black watercolour pan

round watercolour brush (size 4)

STEP 1

The farm building is the main form in the composition, so I began by drawing this with my HB propelling pencil, using the two-point perspective technique. Notice how lines extended from the two vanishing points are used as guides for the windows so that they appear in the same perspective alignment as the rest of the building. I lightly sketched in a couple of trees on each side of the building to frame it and then began to work upon the foreground detail of the cows. I drew perspective lines which taper to a distant vanishing point and used these to help me gauge the size of the cows. Once I had sketched in their forms, I lightly drew in some lines to suggest a pathway.

STEP 2

Using the 0.3mm pigment liner, I inked over my pencil marks. I decided to change the placement of the pathway, making it taper into the distance to give the landscape a stronger feeling of depth. I then added some lines to suggest rolling hills in the far distance. Once the ink lines were dry I erased all my preliminary pencil lines.

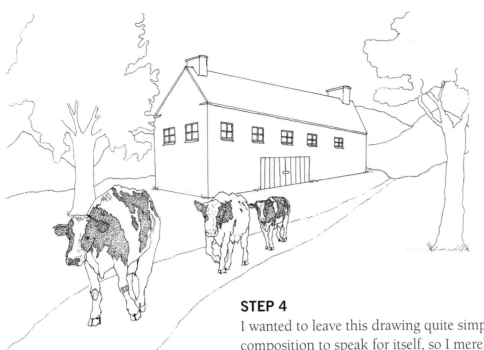

STEP 3

I added some more line details to the windows and doors of the farm building using the 0.3mm liner and then, with the 0.1mm liner, I started to stipple shading on to the cows.

STEP 4

I wanted to leave this drawing quite simple to allow the perspective of the composition to speak for itself, so I merely added light washes to the trees, hills and pathway. I added some brick detail to the front of the building because I felt this helped to give substance to the façade. Finally I added a few sketchy lines to the areas either side of the path to suggest tufts of grass, leaving this surrounding area quite light to throw the cows and receding path into focus.

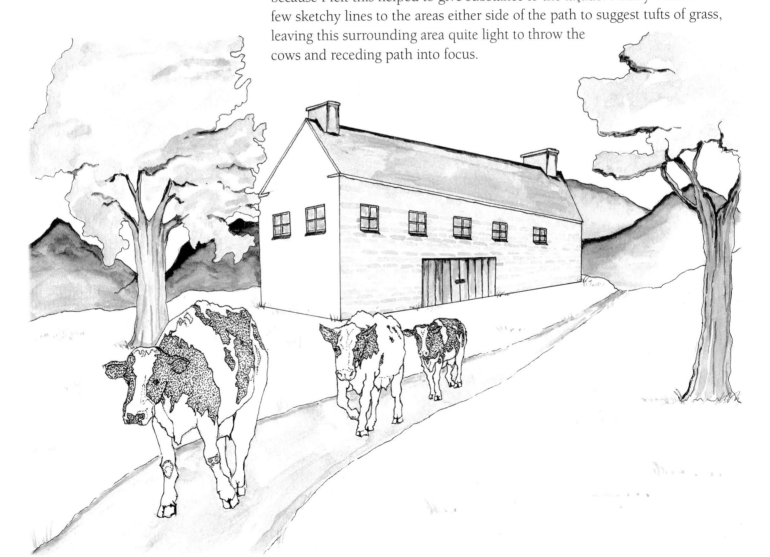

Focal Points and Overlapping

As we have seen, focal points can be established by organizing them according to the rule of thirds. They can be further emphasized by contrasting them with their surrounding area, which can be done by making the focal point tonally much darker or lighter than the background and/or working up the detail of the focal point while the background is left in a soft, blurred focus.

OVERLAPPING

A good way of establishing a visual connection between multiple elements of focus is by overlapping objects. Overlapping elements can also convey depth in your drawing and add to the feeling of the solid three-dimensional scene you are trying to evoke.

You will need

160gsm (98lb) fine-grain

 cartridge paper

HB propelling pencil

2B sketching pencil

6B sketching pencil

MEERKATS ON THE LOOKOUT

I love the attentive little faces of meerkats on the lookout for danger, and their habit of grouping closely together makes them ideal to show off the effectiveness of overlapping forms to create an interesting and integrated composition.

I felt that a pyramid organization of the group of meerkats would make a beautifully balanced and cohesive composition. The diagram shows how the composition has been organized using a pyramidal structure. The highest point of the pyramid is at the centre and acts as the focal epicentre.

STEP 1

I lightly sketched in two lines with an HB propelling pencil to demarcate the top of the pyramid and this helped me to gauge what size I should draw each animal. I then sketched in their forms, making sure each individual either overlapped or was very close to its neighbour. This really helps to tie the forms together as a group.

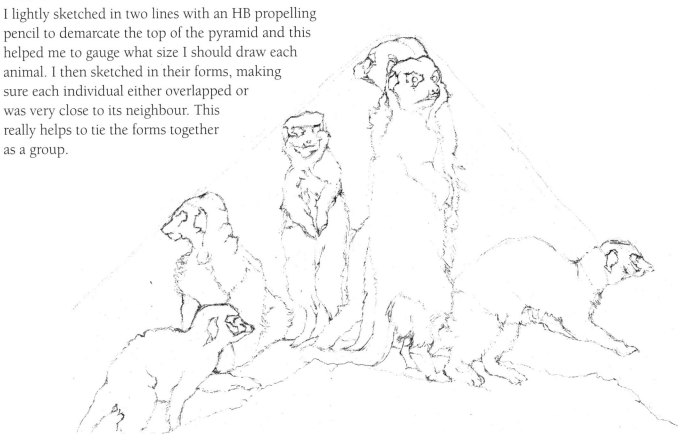

STEP 2

Using the 6B pencil, I shaded in the mask-like eye patches that characterize the meerkat and darkened the ears. I felt it was important to work on the detail of the meerkats' faces first because this composition is all about eyes looking out for imminent danger. Making the eye area tonally darker at this early stage ensures that this will remain a focal element of the drawing. I then erased the pyramid guidelines.

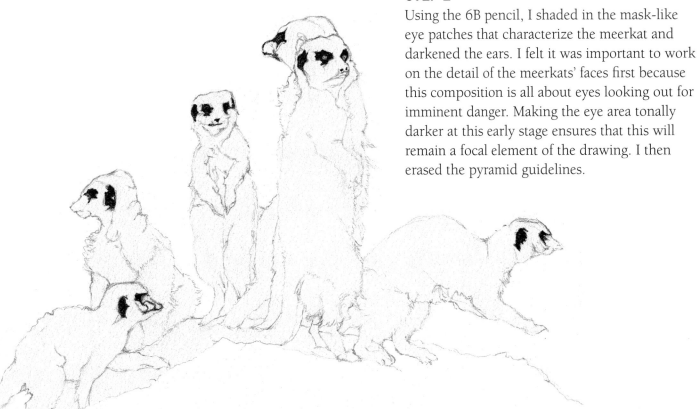

STEP 3

With the 2B pencil, I began to work on evoking the furry texture and mottled pattern of the meerkats' bodies. I held the pencil at right angles to the paper and used small circular motions to scumble the shading on to the paper. Using this scumbling technique darkens the tone and at the same time produces variation in texture.

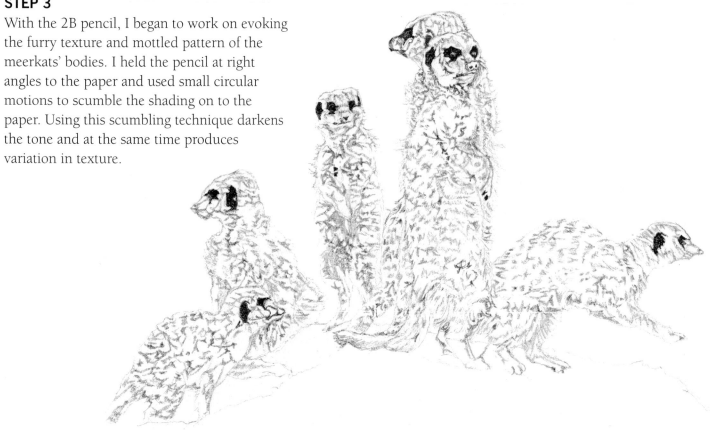

STEP 4

At this stage the forms were all beginning to look a bit blurry and undefined, so I started to define the shading and outlines of the meerkats with the 6B pencil. Darkening the outlines helps the meerkats to stand out from each other visually as individuals within the group.

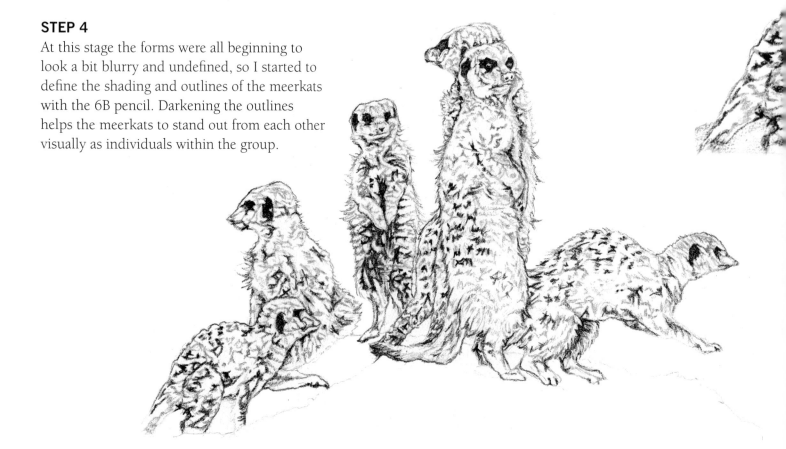

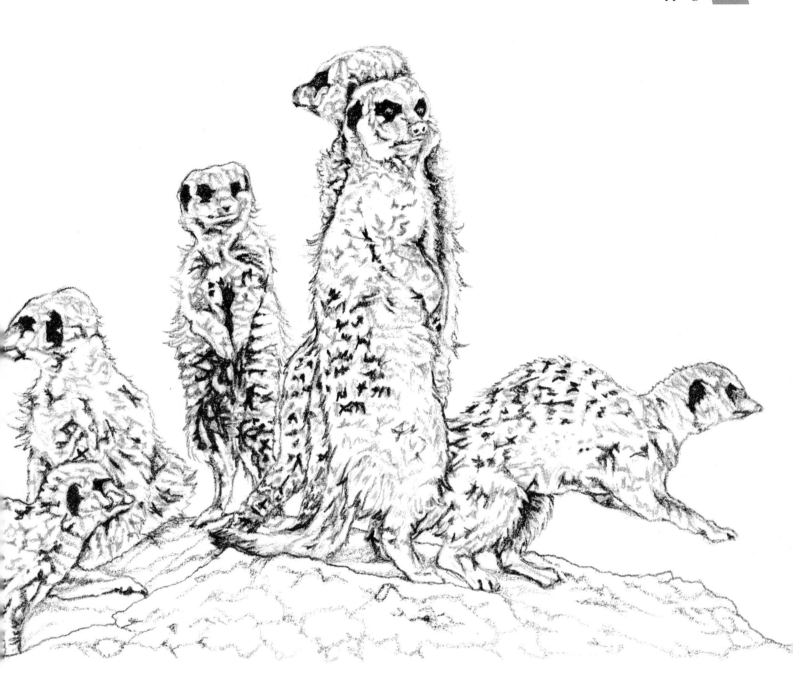

STEP 5

Finally I added some rough shaded patterns to the mound upon which the group sits. This final touch unites the composition, giving the meerkats a grounded 'anchor', tying the individuals together into a cohesive, unified group.

Balancing Compositions

An unbalanced scene can appear awkward and uninteresting to look at. There are several ways to balance your compositions to ensure they look harmonious.

SYMMETRICAL BALANCE

Making each side of your picture mirror the other is the simplest approach to balancing a composition. The centre between the two halves becomes the focus. This can make for bold compositions, but if you're not careful it can be very formulaic and uninteresting. Try to avoid this by adding slight variation between the two halves of your composition. Small details, for example a tree or building which is present on one side but not the other, can give your symmetrically devised compositions a natural feel without disrupting the notion of symmetry.

ASYMMETRICAL BALANCE

This approach is often much more effective but takes a little more thought and planning. Asymmetric balance is about establishing contrast between two elements which interact and balance each other out by their very difference. These elements can differ in tone, size, shape or texture. So if one half of your composition is dark, this can be balanced by making the other half tonally lighter.

BROWN BEAR

Bears are extremely skilful hunters; seeing them stand in fast-flowing waters waiting to seize the spawning salmon is an extraordinary sight. Here I wanted to capture the fast pace of the action, show the direction of the flow of water and make the viewer anticipate the fish's capture. I used asymmetric balance of tone to make the composition really powerful.

You will need

160gsm (98lb) fine-grain cartridge paper

HB propelling pencil

charcoal pencil

tortillon

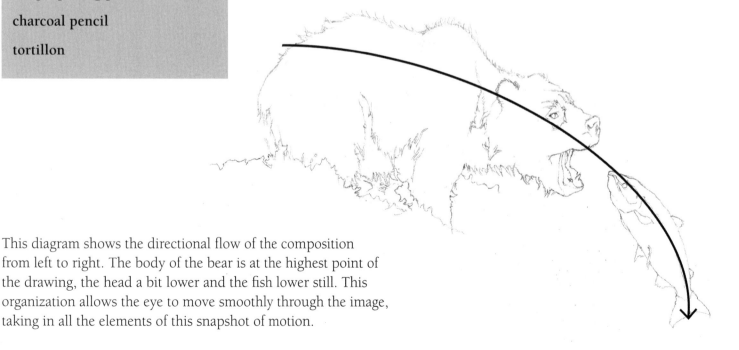

This diagram shows the directional flow of the composition from left to right. The body of the bear is at the highest point of the drawing, the head a bit lower and the fish lower still. This organization allows the eye to move smoothly through the image, taking in all the elements of this snapshot of motion.

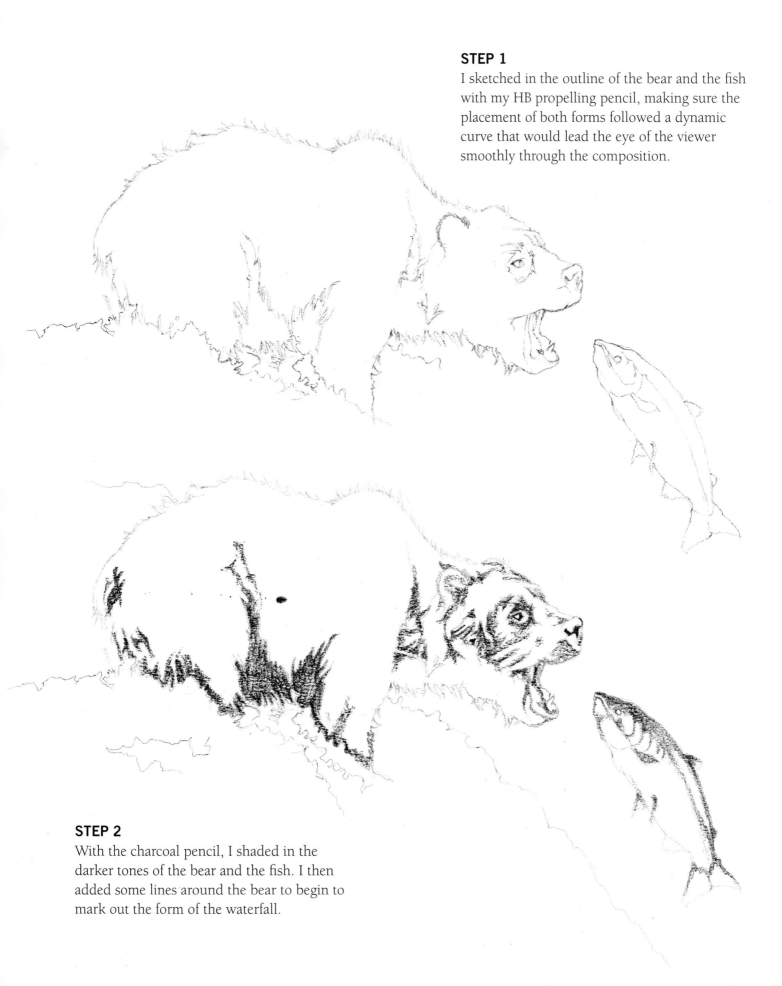

STEP 1

I sketched in the outline of the bear and the fish with my HB propelling pencil, making sure the placement of both forms followed a dynamic curve that would lead the eye of the viewer smoothly through the composition.

STEP 2

With the charcoal pencil, I shaded in the darker tones of the bear and the fish. I then added some lines around the bear to begin to mark out the form of the waterfall.

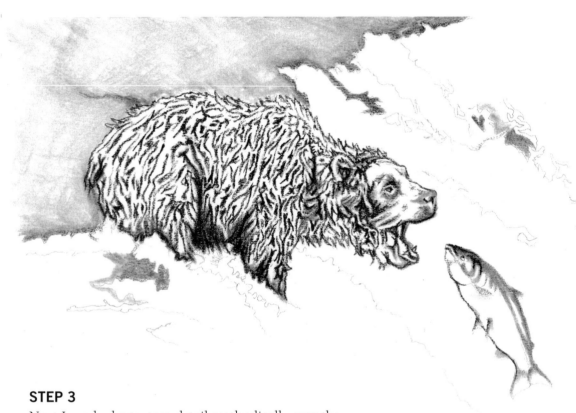

STEP 3

Next I worked a texture detail methodically over the surface of the bear to express its furry coat. I used the tortillon to smudge a mid-tone into the area of water behind the bear, then added more wavy line detail to help to describe the flowing waters.

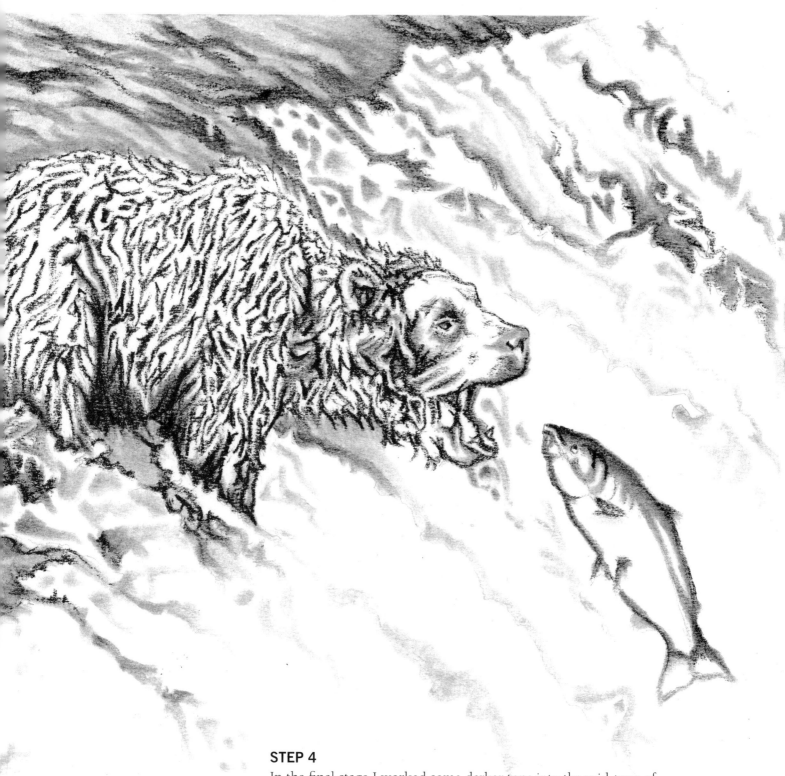

STEP 4

In the final stage I worked some darker tone into the mid-tone of the waters behind the bear and used the tortillon to extend some wavy smudged lines into the lighter waters in front. I was careful not to over-work this lighter area because I wanted to preserve the stark tonal contrast between the light and dark halves of the composition. This contrast, which divides the picture diagonally, really adds to the dynamic motion of the action.

INDEX